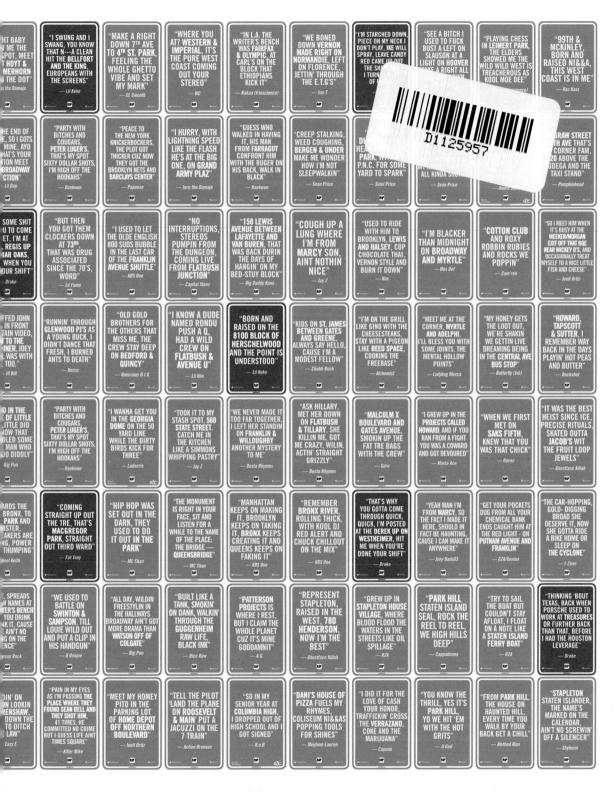

THE "RAP" QUOTES COAST TO COAST

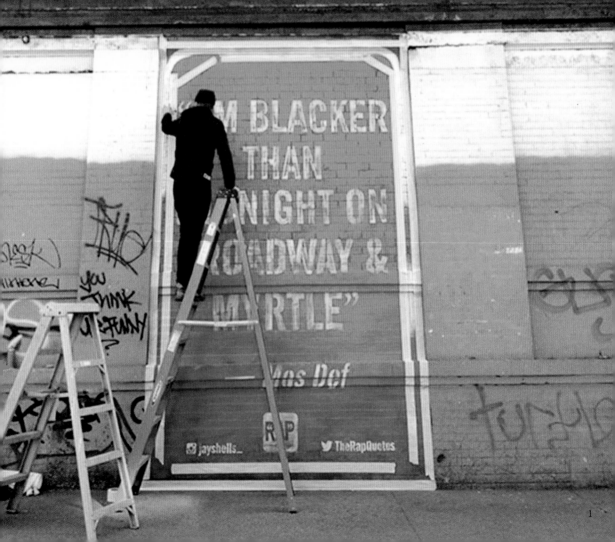

"M BLACKER
THAN
NIGHT ON
ROADWAY &
MYRTLE"

— Mos Def

RAP

jayshells_ TheRapQuotes

THE RAP QUOTES: COAST TO COAST
A photographic catalog and maps of site-specific rap lyrics in New York,
Los Angeles, Philadelphia, Atlanta, Houston and more.

©2019 Dokument Press and Jason Shelowitz
First printing 2019
Printed in Poland
ISBN 978-91-88369-19-2

Photos: Aymann Ismail unless otherwise noted. www.aymann.com
Text: Ernest Baker, Cassie Owens, Jensen Karp, Maurice Garland,
Lance Scott Walker
Editor: Stephanie Huszar
Foreword: Jason Shelowitz (Jay Shells) www.jayshells.com
Graphic design: Jason Shelowitz (Jay Shells)
This book is typeset in Trade Gothic Condensed No. 18 and
Trade Gothic Bold Condensed No. 20

Thank you to my wife Rachel who has supported this major effort since the
beginning; Sadie and Isobel (it's all for you); Bradster for being a part of this
from day one; Jordan for constantly feeding me good music over the years;
Dad (RIP) for providing me a musical house to grow up in; Mom & Ron for the
constant support; Holly; Randi; Shay; Zack; Kasey; Steve & Kathy Weiner (my
CA parents); Chris, Jen, Chase, Avery & Brooks; Jordan & Vicky; Jamie; Julien;
Greyson; Aymann Ismail; Bucky Turco; Marina Galperina; Andy Cush; Rob
Lambert; the Anderson family; PRT Crew; Oceanside; JMZ Walls; Rocko & Spread
Art; Bobby Blunts; Björn Almqvist & Dokument Press; Matador Content and
team; Fillin Global; DJ SNAFU; Opto; AAB; I250; Cip One; Mike Walbert;
Jade Carter & A3C famalam; Ernest Baker; Cassie Owens; Jensen Karp,
Maurice Garland; Lance Scott Walker; Stephanie Huszar; Jesse Sendejas;
Andrew Marantz; Bob Garfield & Smart Source; everyone who has helped to
supply lyrics and shown local support in every city; every rapper, producer and
engineer responsible for making the music I love; every writer and journalist
who has helped to spread the word about what I do; and lastly, one of the
greatest lyricists that ever was—and the inspiration for this project, Big L (RIP).

Dokument Press
Box 773
120 02 Årsta, Sweden

info@dokument.org
dokument.org

It all started with a Twitter account. My younger brother Brad and I started @TheRapQuotes as a fun way to share our favorite rap lyrics. When the idea struck to highlight site-specific lyrics as a street art campaign, it seemed only right to call it by the same name. I've always had a serious passion for lyricism, partly because I've always been envious of people who are gifted with words.

It was January 2013. I was working on a painting and listening to Big L's *Lifestylez ov da Poor and Dangerous* album for the 100th-plus time. But this time, it was different. The lyrics "on 1-3-9 and Lenox Ave. there's a big park, and if you're soft don't go through it when it gets dark" triggered an idea. What if somehow these lyrics existed visually, in the exact location mentioned? The work of *Trustocorp* had inspired me to use street signs a few years earlier for another project, and it turns out that was the best medium for this idea as well.

With the help of a few friends, I very quickly collected 30 sets of site-specific lyrics for the New York area. My friend Bucky ran a magazine and website called Animal New York, and when I told him about the project, he wanted to be involved. He introduced me to his newly hired photographer and videographer, Aymann Ismail, at a party on a Friday night in early March 2013. We hit the streets early the next morning to get the 30 signs up, with Aymann documenting the process. About a week later, they posted the video and photos with a short write-up, and the rest is history. Since then, Aymann and I have travelled to Philadelphia, Los Angeles, Atlanta and Houston, documenting everything along the way. The project sometimes takes the shape of billboards, bus stop and phone booth advertising takeovers and painted murals, but mostly, the lyrics are displayed as street signs. So far, I have installed over 400 around the country, with many more to come.

Please enjoy this collection of Aymann's photography, along with a few from Rob Lambert and myself.

JASON SHELOWITZ (JAY SHELLS)

To the residents of Chicago, the Bay Area, New Orleans, D.M.V., Miami and other cities around the U.S. and the world: You have not been overlooked; we will get there. This book represents where the project has been installed from 2013—2018.

NEW YORK

*Manhattan, Queens, Brooklyn, Bronx, Staten Island,
Long Island and Mount Vernon*

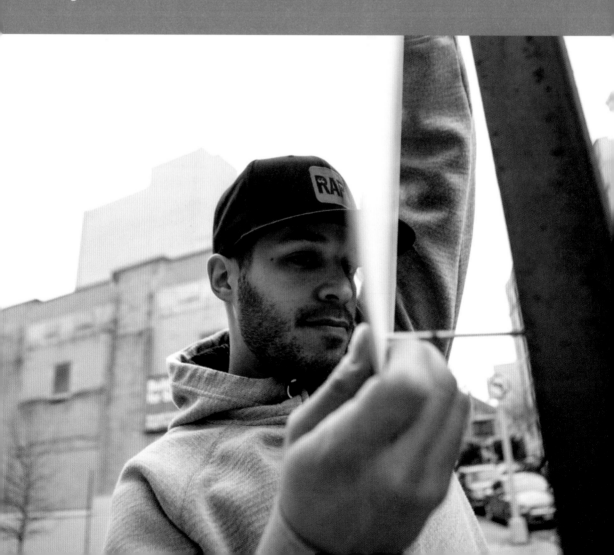

"August 11, 1973. 1520 Sedgwick Avenue. The Bronx, New York.

It was on this summer night, at this location, during a back-to-school party, that DJ Kool Herc pioneered the art of making music with two turntables and a mixer, effectively birthing hip hop.

As time has passed, and the genre has assumed more of a post-regional identity, the iconography of hip hop is still inseparably tied to the five boroughs.

And for good reason.

Grandmaster Flash. Afrika Bambaataa. Kurtis Blow. Run DMC. Beastie Boys. LL Cool J. Rakim. Kool G Rap. Public Enemy. KRS-One. Big Daddy Kane. De La Soul. A Tribe Called Quest. Wu-Tang Clan. Nas. Gang Starr. Mobb Deep. The Notorious B.I.G. Jay Z. Busta Rhymes. Lil Kim. Big L. Foxy Brown. Diddy. Big Pun. DMX. The Lox. Mos Def. Ja Rule. Cam'ron. 50 Cent. Nicki Minaj. ASAP Rocky. Cardi B. Sheck Wes.

All of these artists, from all of these eras, made their names in New York. And that's a short list, all things considered. The generational breadth of the city's talent is incomparable.

Even Tupac was born in Harlem.

No other location packs a more comprehensive story of hip hop's ascent over the past several decades than New York.

Even as the internet casts the net of what was already a global phenomenon wider—granting anyone, anywhere the power to find success as a rapper—the conversation somehow always comes back to New York.

The city is special in a way that's felt more than described.

History surrounds you in Bedford-Stuyvesant. Legacy follows you in Queensbridge. Spend any amount of time here and the culture will envelop you. Hip hop is inextricably linked to these streets and even as it's become the world's most popular music, the artists here keep a chip on their shoulder because they know that none of this would really be possible without their city.

In a way, documenting the Rap Quotes of New York is the greatest responsibility in this series. There's a ridiculous amount of ground to cover, conceptually and literally. More than a random assortment of popular lyrics, you're chronicling the growth and proliferation of a groundbreaking art form from the very point of its inception.

When you see these iconic avenues and world-famous neighborhoods for the first time, you feel like you've already been here. When the landmarks transcend music, a new level of appreciation washes over you. The understanding that real people built this culture from the ground up on the same pavement on which you walk is priceless.

They call New York the Mecca for a reason."

ERNEST BAKER

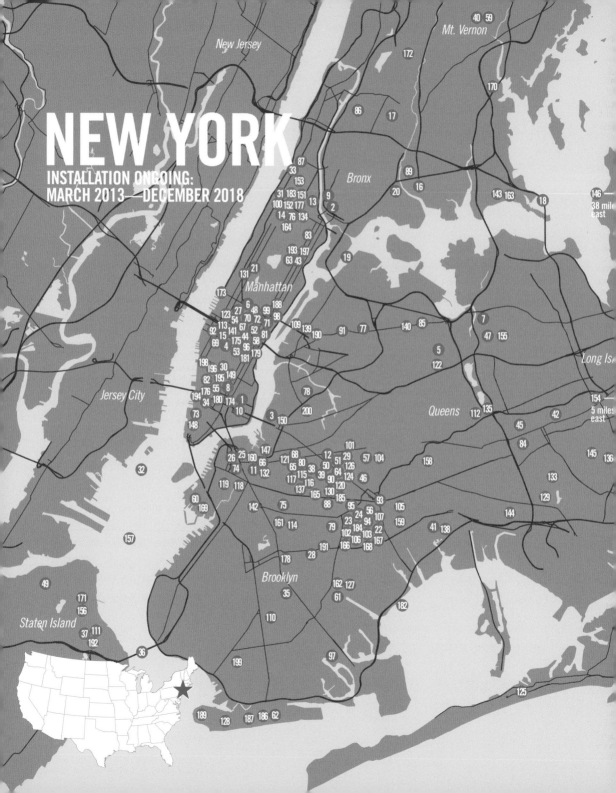

th Sense:
"very third weekend, was at the **Nuyorican**,
was underage so I used to have to sneak in"

G.:
atterson Projects is where I rest, but I claim the whole
anet cuz it's mine goddamnit"

ction Bronson:
all my **Peter Luger** junior, Keens Chop House in shorts"

ction Bronson:
all my **Peter Luger** junior, **Keens Chop House** in shorts"

ction Bronson:
atch a case, post bail, then I flee to Tacoma come back,
ew face, **103 & Corona**"

ction Bronson:
armesan crisp, we wildin' in **Marea**, doin' all the drugs
f of Pico & La Brea"

ction Bronson:
ll the pilot land the plane on **Roosevelt & Main**, put a
cuzzi on the 7 train"

ction Bronson:
arsh as a Russian winter, still we dinin' at **Lupa**, right
ere on **Bleecker & Thompson** eatin' a custom dinner"

esop Rock:
ense, spreads like new names at the **Writer's Bench**,
ther you drink it or sink it, cause there ain't no sitting
the fence"

chemist:
n on the grill like Gino with the Cheesesteaks, stay with
pigeon like **Reed Space**, cooking the freebase"

ekay:
y ass is off probation **Junior's Cheesecake** almost sold
r $50 Mil, but wouldn't change the location"

g Daddy Kane:
8 Lewis Avenue between Lafayette and Van Buren,
at was back durin' the days of hangin' on my
ed Stuy block"

g L:
139 & Lenox Ave** there's a big park, and if you soft
n't go through it when it gets dark"

g Noyd:
mped up in the bubble, yo kid where are you?
14 between Manhattan and Morningside Avenue)
is happened just right out the blue"

g Pooh:
e and Mick B we were chillin' at the **Hammerstein**, I
ticed you as I headed toward the exit sign"

g Pun:
day wildin', freestylin' in the hallways, Broadway ain't
t more drama than **Watson off of Colgate**"

g Pun:
ad in the **middle of Little Italy**, little did we know that
e riddled some middle man who didn't do diddly"

gg Jus:
om the **Throgs Neck Bridge** to the Hells Gate,
rically detonating"

gg Jus:
om the Throgs Neck Bridge to the **Hells Gate**,
rically detonating"

gg Jus:
ganized graffiti lectures in can control, or level with
e devil racing uptown first to **Fort Apache**"

ack Rob:
mp in the whip, get them cats I wanted to get since
e **Tavern on the Green** robbery in '86"

uckshot:
ward, Tapscott & Sutter**, I remember way back in the
ys playin' hot peas and butter"

23 Buckshot:
"On **Rockaway & Livonia** I see this other chick Sonia,
she'll try to blow ya and she swear she own ya"

24 Buckshot:
"6 o'clock friday in front of **Tilden**, all I see is cops,
somebody shot in the buildin'"

25 Busta Rhymes:
"Ask Hillary, met her down on **Flatbush & Tillary**, she killin'
me, got me crazy, wilin', actin' straight grizzly"

26 Busta Rhymes:
"We never made it to far together, I left her standin' on
Franklin & Willoughby another mystery to me"

27 Busta Rhymes:
"Yes, yes yall, you know we talkin' it all, see how we
bringin' the street corner to **Carnegie Hall**"

28 Busta Rhymes:
"Before I set it off and show what I'm gonna do to ya,
possess the bomb chocolate from off **Linden & Utica**"

29 Butterfly (ish):
"My honey gets the loot out, we're shakin', we gettin' live
dreaming being in the **Central Ave bus stop**"

30 Cam'ron:
"He had the Honda Accord, made it more sweet, we balled
every summer like **West 4th Street**"

31 Cam'ron:
"**Cotton Club** and Roxy Robbin Rubies and rocks we poppin'"

32 Cam'ron:
"You get no chicks, that's no mystery, the last girl you
been in, **Statue of Liberty**"

33 Cam'ron:
"I represent where them killers at **145th & Broadway** you
get your head cracked"

34 Cam'ron:
"Yo subliminal thoughts, **100 Centre Street Criminal
Court**, pissy drunk up in here, brought in gin to court"

35 Capital Steez:
"No interruptions, stereos pumpin' from the dungeon,
coming live from **Flatbush Junction**"

36 Capone:
"I did it for the love of cash your honor, traffickin' cross
the **Verrazano**, coke and the marijuana"

37 Cappadonna:
"**Park Hill Staten Island** seal, rock the reel, we high hills deep"

38 Chubb Rock:
"Kids on **St. James between Gates and Greene**, always
say hello, cause I'm a modest fellow"

39 CJ Fly:
"Ever since I was a snot nose, grew up close to **Kosciuszko**"

40 CL Smooth:
"Make a right down **7th Ave to 4th St. Park**, feeling the
whole ghetto vibe and set my mark"

41 Daddy O (Stetsasonic):
"And then I take a trip to **Pink Houses**, check out the girls
with the pretty pink blouses"

42 Das Racist:
"I'm at the Pizza Hut (WHAT?) I'm at the Taco Bell (WHAT?)
I'm at the **combination Pizza Hut & Taco Bell**"

43 Dice Raw:
"Built like a tank, smokin' on dans, walkin' through the
Guggenheim raw life, black ink"

44 Eminem:
"When I'm down to my last breath, I'ma climb the **Empire
State Building** and get to the last step and still have
half left"

45 Everlast:
"I always **switch trains in Jamaica Queens** when I go to
Valley Stream to see my Aunt Eileen"

46 Fabolous:
"I'm what chicks strive to get, I stay in the pj's you thinkin'
Breevort, I'm talkin' private jets, uh"

47 Fashion (Al' Tariq):
"Back in the days **I.S. 237**, used to run with Kevin,
baggin' hoes was like heaven"

48 Ghostface Killah:
"It was the best heist since ice, precise rituals, skated
outta **Jacob's** with the fruit loop jewels"

49 Ghostface Killah:
"Represent Stapleton, raised in the west, **780 Henderson**,
now I'm the best"

50 GURU:
"**Malcolm X Boulevard & Gates Avenue**, smokin' up the
fat tre bags with the crew"

51 GZA/Genius:
"Get your pockets dug from all your Chemical Bank ends,
caught him at the red light—on **Putnam Avenue & Franklin**"

52 GZA/Genius:
"I took her off the showroom floor, no money down, near
the **Chrysler Building** in the heart of midtown"

53 GZA/Genius:
"**On 34th street in the Square of Herald**, I gamed Ella,
the bitch caught a fitz like Gerald"

54 GZA/Genius:
"Restaurants on a stake-out, so order the food to take out,
chaos outside of **Sparks Steakhouse**"

55 GZA/Genius:
"Thought he saw me on **4th & Broadway** but I was out on
the Island, bombing MCs all day"

56 GZA/Genius:
"Back on the ave of **Livonia & Bristol** with a pistol,
stickin' up Pamela and Crystal"

57 GZA/Genius:
"High price to pay for a small reward, kill for that
Bushwick & Halsey broad"

58 Havoc:
"When we first met on **Saks Fifth**, knew that you was that chick"

59 Heavy D:
"Now **4th Street Park** after dark is dangerous, might get
clapped if you look strange to us"

60 Hell Razah:
"Welcome to Red Hook, this ain't Jamrock,
F train Smith & 9th get off the last car"

61 Ill Bill:
"I snuffed John Hayes in front of Captain Video, next to
the **Arch Diner**, Joey Haskell was with me too"

62 J Zone:
"The car-hopping, gold-digging broad she deserve it,
now she gotta ride a bike home or sleep on the **Cyclone**"

63 J-Live:
"From the Louvre Museum to the **Guggenheim**, you could
set the time to a J-Live rhyme"

64 J-Live:
"Playing loud at a shop right on **Fulton & Throop**,
'til a Jeep drowned it out with Xzibit and Snoop"

65 Jay Z:
"Cough up a lunch where I'm from, **Marcy** son,
ain't nothin' nice"

66 Jay Z:
"Took it to my stash spot, **560 State Street**, catch me
in the kitchen like a Simmons whipping pastry"

67 Jay Z:
"Ya chick shop at the mall, my chick burnin' down
Bergdorf's, comin' back with Birkin bags"

68 Jay Z:
"Grew up on Lexington Ave, my socks real high, moved
to **Marcy Projects** 'round the time I was five"

7

69 Jay Z:
"**Christie's** with my missy, live at the MoMA, bacons and turkey bacons, smell the aroma"

70 Jay Z:
"Christie's with my missy, live at the **MoMa**, bacons and turkey bacons, smell the aroma"

71 Jay Z:
"How many times can I go to **Mr. Chow's**, Tao's, Nobu, hold up, lemme move my bowels"

72 Jay Z:
"How many times can I go to Mr. Chow's, **Tao's**, Nobu, hold up, lemme move my bowels"

73 Jay Z:
"How many times can I go to Mr. Chow's, Tao's, **Nobu**, hold up, lemme move my bowels"

74 Jeru Tha Damaja:
"Aight baby show me the exact spot, meet me at **Hoyt & Schermerhorn** at 3 on the dot"

75 Jeru the Damaja:
"I hurry, with lightning speed like the Flash, he's at the big one, on **Grand Army Plaz**'"

76 Jim Jones:
"You know I claim (what you claim?) where them gangstas bang **15th and Lenox**, 9-tre, they do they own thing"

77 Joell Ortiz:
"Meet my homey Pito in the **parking lot of Home Depot off Northern Boulevard**"

78 Joell Ortiz:
"So I meet him when it's busy at the **Meeker/Morgan exit off that BQE near Micky D's** and occasionally treat myself to a nice little fish and cheese"

79 Joey Bada$$:
"My city be on the genesis for where they think the terror is, they linking terrorists from the Stuy to **Lincoln Terraces**"

80 Joey Bada$$:
"Yeah man I'm from **Marcy**, so the fact I made it here, should in fact be haunting, cause I can make it anywhere"

81 Kanye West:
"But I ain't even gonna act holier than thou, cause fuck it, I went to **Jacob** with 25 thou"

82 Kanye West:
"But by the black album, I was blacking out party at **S.O.B.'s** we had packed the crowd"

83 Kanye West:
"Cause I want to be on **106 & Park** pushing a Benz"

84 Killer Mike:
"Pain in my eyes as I'm passing **the place where they found Sean Bell and they shot him**, 41 times, he committed no crime but I guess life ain't Times Square"

85 Kool G Rap:
"Hear it when I get biz for K-Von, I'm pledgin', died on **104 Northern Boulevard**, Corona Queens legend"

86 Kool Keith:
"Towards the South Bronx, to **Cedar Park** and Webster, the speakers are pumping, power bass is thumping"

87 Kool Moe Dee:
"I used to live downtown, **129th Street, Convent**, everything's upbeat, parties, ball in the park"

88 KRS One:
"I used to let the Olde English 800 suds bubble in the last car of the **Franklin Avenue Shuttle**"

89 KRS One:
"Remember **Bronx River**, rolling thick, with Kool DJ Red alert and Chuck Chillout on the mix"

90 Ladybug Mecca:
"Meet me at the corner, **Myrtle & Adelphi**, I'll bless you with some joints, the mental hollow points"

91 Large Professor:
"Nice to have you, 57th Avenue, **Steinway Street, Northern**, Kissena Boulevard, 4-5th"

92 Lauryn Hill:
"Sometimes he thought of the fame in **Madison Square Garden**, so some seek stardom, but they forget Harlem"

93 Lil Dap:
"It's the end of the time, so I gots to get mine, ayo 'Ru, what's your function? meet me at **Broadway Junction**"

94 Lil Fame:
"But then you got them clockers down at **73rd**, that was drug associated since the 70s, word"

95 Lil Fame:
"Somebody talk to homey tell him I don't play ball, you fuckin' with them **Saratoga** hackers **off of St. Marks**"

96 Lil Kim:
"Cruise the **Diamond District** with my biscuit flossing my Rolex wrist shit"

97 Lil Kim:
"I know a dude named Rondu push a Q, had a wild crew on **Flatbush & Avenue U**"

98 Lil Kim:
"Sipping zinfandel up in Chippendales shopping **Bloomingdale's** for Prada bags female don dada ha"

99 Lodeck:
"While he was alive, had the humblest soul, of a middle-class dropout wantin' to travel the world, but his life was the **F train—Lex & 63rd**"

100 Ma$e:
"I done hit everything from Cancun to **Grant's Tomb**"

101 Maffew Ragazino:
"Buster Douglas uppercut like when Mike lost, in 08 I used to take the **L up from Wyckoff**"

102 Maffew Ragazino:
"I'm such a Rockaway n---a, peace to the other side, **Mother Gaston, Dumont**, Livonia, Sutter side"

103 Masta Ace:
"I grew up in the **Projects called Howard**, and if you ran from a fight you was a coward and got devoured"

104 Masta Ace:
"I used to hang a lot in Bushwick, **Decatur & Evergreen**, some of the best parties you ever seen"

105 Masta Ace:
"Now we both runnin' frantic, in a panic, I got caught on **Pennsylvania & Atlantic**"

106 Masta Ace:
"Walkin down **Thatford & Pitkin** I see this chicken named Lisa, shoppin with a Platinum Visa"

107 Masta Ace:
"On **Saratoga & Sutter**, feelin' like my life in the gutter, bout to go all out with a box cutter"

108 MC Serch:
"On the streets of Far Rockaway Queens, **Edgemere Wavecrest by Beach 17**"

109 MC Shan:
"Hip hop was set out in the dark, they used to do it out in the **Park**"

110 MCA:
"Used to ride the D to beat the morning bell, at **Edward R. Murrow out on avenue L**"

111 Method Man:
"From **Park Hill**, the house on haunted hill, every time you walk by your back get a chill"

112 Meyhem Lauren:
"**Dani's House of Pizza** fuels my rhymes, coliseum n---as popping tools for shines"

113 Mike D & MCA:
"I think her name is Lucy but they all call loose, I think I thought I seen her on **Eighth & Forty-Deuce**"

114 Mos Def:
"We can play nice and decent, or dirty like the **71 Precinct**, make it a short day or a long evenin'"

115 Mos Def:
"From **Sumner** to Tompkins, to Lafayette Gardens, Wyckoff, Gowanus, in their army jacket linings"

116 Mos Def:
"From Sumner to **Tompkins**, to Lafayette Gardens, Wyckoff, Gowanus, in their army jacket linings"

117 Mos Def:
"From Sumner to Tompkins, to **Lafayette Gardens**, Wyckoff, Gowanus, in their army jacket linings"

118 Mos Def:
"From Sumner to Tompkins, to Lafayette Gardens, **Wyckoff**, Gowanus, in their army jacket linings"

119 Mos Def:
"From Sumner to Tompkins, to Lafayette Gardens, Wyckoff, **Gowanus**, in their army jacket linings"

120 Mos Def:
"I'm blacker than midnight on **Broadway and Myrtle**"

121 Mos Def:
"Where you go to get the fresh trim at, **Fulton & Jay** the Timb rack"

122 N.O.R.E.:
"**Lefrak** is Iraq, illegal life contract, keep 'em back, load up the big macs"

123 Nas:
"Take her out to the **Sparks Steakhouse**, gentleman style, coincidental"

124 Nas:
"We sippin' on merlot, you ain't gon be my girl though, I drop you off at **Willoughby & Myrtle**"

125 Nas:
"Meetin' out in beach channel with peeps from **Hammels**"

126 Nas:
"Used to ride with him to Brooklyn, **Lewis & Halsey**, cop chocolate thai, Vernon style and burn it down"

127 Necro:
"Runnin' through **Glenwood pj's** as a young buck, I didn' dance that fresh, I burned ants to death"

128 Nems:
"**O'Dwyer Gardens, building 6**, that's where you could find me, I'll mush your face through the window of the building lobby"

129 Nicki Minaj:
"I be on **147 & the Rock** that's my block, New York City to the top, tippy top buss a shot"

130 Notorious B.I.G.:
"Old Gold Brothers for the others that miss me, the crew stay deep on **Bedford & Quincy**"

131 Notorious B.I.G.:
"N---a, is you creepin' or speakin'? He tells me C-Rock just got hit up at the **Beacon**"

132 Papoose:
"Peace to the New York Knickerbockers, the plot got thicker cuz now they got the Brooklyn Nets and **Barclays Center**"

133 Pharoahe Monch:
"His momma said, 'Donovan why are you, **on the corner of Linden and Guy R. Brew**?'"

134 Pharoahe Monch:
"That's when I made a promise to my momma, I said I betcha you'll see me at **the Apollo** one day and I'ma"

haroahe Monch:
"s the most incredible rap individual style piles up like
rug cases in **Queens County Criminal Court**, shorty,
ep back"

hife Dawg:
vin' off **Linden**, **192nd**, chillin' at the rest, other
rothers wreck it"

rodigy:
eace to my **Sumner Villains** and Pink Houses from Red
ook to QB, you know the routine"

rodigy:
eace to my Sumner Villains and **Pink Houses** from Red
ook to QB, you know the routine"

rodigy:
n a **park bench on 12th street** my whole crew's famous,
u try bust your gat and keep it real but you nameless"

sycho Les:
om **Northern Boulevard, straight up Junction** my
ystem got the beat in full function"

uff Daddy:
ut treat dimes fair, and I'm bigger than the city lights
own in **Times Square**"

umpkinhead:
egraw Street & 5th Ave. that's my corner fam,
20 above the bodega and the taxi stand"

Unique:
e used to battle on **Swinton & Sampson**, 'till Louie wild
ut and put a clip in his handgun"

-Tip:
ove down the **Belt got on the Conduit**, came to a toll
e paid and went through it"

-Tip:
est on **191 116th Ave., off of Farmers Boulevard**"

A the Rugged Man:
go to **Smithhaven Mall** to see if anybody want some,
nybody want some of this it's gonna cost 'em"

aekwon:
uess who walked in having it, his man from **Farragut**,
nfront him with the ruger in his back, walk in black"

aekwon:
lling glass and blasting, machinery sling past, next
op: **Bowling Green**, bling flashing"

aekwon:
nalyzin' miss Clairol, Fendi'd down mascara on,
ssistant manager in **Paragon**"

aekwon:
rty with bitches and cougars, **Peter Luger's**, that's
y spot sixty dollar shots, I'm high off the hookahs"

akim:
mateur night showtime at **the Apollo**, probably be
atching Bill Cosby tomorrow"

edman:
ollin' 'round the blid-ocks, I rock round the clid-ock, my
d-ock cocked from here to **16th and Lenox**"

edman:
y man slangs rocks like up the block,
3rd & Amsterdam by the smoke shop"

oc Marciano:
ang a billionaire heiress on the terrace, I'm from
rrace, my sellers twist vanillas"

oyal Flush:
u know who I'm talkin to the best chosen laying on
th & Colden, sellin' drugs 'til the mornin'"

ZA:
ew up in **Stapleton House Village**, where blood flood
e waters in the streets like oil spillage'"

157 RZA:
"Try to sail the boat but couldn't stay afloat, I float on a
note like a **Staten Island Ferry** boat"

158 RZA:
"Old Dirty stalked East New York, GZA maintained
Franklin Lane I was going to Thomas the Jeff, where
students got slain"

159 RZA:
"Old Dirty stalked East New York, GZA maintained
Franklin Lane I was going to **Thomas the Jeff**, where
students got slain"

160 RZA:
"These young Gods was seekin' Hoes in **Westinghouse**
and Clara Barton in Medina"

161 RZA:
"These young Gods was seekin' Hoes in Westinghouse
and **Clara Barton** in Medina"

162 Sabac Red:
"Explode from out the projects, **Glenwood** to Throgs Neck
hold your drink up, and make a toast to how the gods get"

163 Sabac Red:
"Explode from out the projects, Glenwood to **Throgs Neck**
hold your drink up, and make a toast to how the gods get"

164 Sadat X:
"I'm on **110 & Lenox** with these Africans, overseein' our
physical being, and how we doin' it"

165 Sean Price:
"Creep stalking, weed coughing, **Bergen & Under** make
me wonder how I'm not sleepwalking"

166 Sean Price:
"Cut down Dumont then I head to **Bristol Park**, with my
P.N.C. and some yard to spark"

167 Sean Price:
Sean Price from **Seth Low**, nah, I'm from down the block,
Brownsville P's, my n----s squeeze all kinda shots"

168 Sean Price:
Sean Price from Seth Low, nah, I'm from down the block,
Brownsville P's, my n----s squeeze all kinda shots"

169 Shabazz the Disciple:
"We right off Exit 26B, BQE, F train, **Smith & 9th**, last
stop on the G"

170 Sheek Louch:
"Tryin to catch the last movie at **Bay Plaza**, burner on my
waist, dime bags and a dutch master"

171 Shyheim:
"**Stapleton** Staten Islander, the name's marked on the
calendar, ain't no screwin' off a silencer"

172 Slick Rick:
"Stepped on the **D train at 205th**, I saw a pretty girl (so?) so I
sat beside her, then she went roar like she was Tony the Tiger"

173 Slick Rick:
"Wassup dear? Sup babe? What street you by?
On **57th 'bout to hit the West Side High**"

174 Slug:
"**Houston & Ludlow, Max Fish** vampire, you pour the beer
and I'll bring the satire"

175 Smoke DZA:
"Think Christmas, got big tree lit up, no **Rockefeller
Center** shit, this fucking hash tasting sweeter than
some cinnasticks"

176 Smoke DZA:
"Let's rule the world and get these blue notes, uh, watch
Jazz at **The Blue Note**, uh, you can never be too low"

177 Smooth B:
"Sometimes I rhyme slow sometimes I rhyme quick, I was
on **1 2 5 & St. Nick**"

178 Special Ed:
"I'm Special Ed, and yes, I'm takin' it all, the school that
I attend is **Erasmus Hall**"

179 Stalley:
"Fifth floor down on **Saks Fifth**, buying St. Laurent jackets,
dope boys strolling, you can have all that dab shit"

180 Stalley:
"Futuristic on some new shit as usual, you talking bad I'm
like 'who is you?' I'm **Supreme, Lafayette Street** original"

181 Stalley:
"I drop jewels like **47th & 6th**, or get real gangster
and 86 your shit"

182 Starang:
"All the girls that I took to **Canarsie Pier** is in here, my
n---as from Vanderveer is in here"

183 Talib Kweli:
"Teenaged lovers sit on the stoops up in Harlem, holdin'
hands **under the Apollo marquee** dreamin' of stardom"

184 Thirstin Howl III:
"Eddie Lee, forever, in our memories rest in peace, corner
of **Livonia & Chester Street**"

185 Thirstin Howl III:
"**Rockaway 3 train, transfer at Utica**, let me in your
house party or I'll shoot it up"

186 Torae:
"How you thinking he got this inspiration, started with
nathin', right up the block from the **Cyclone & Nathan's**"

187 Torae:
"It ain't gon' get more hood or get more slum than
23rd & Mermaid, that's where I'm from"

188 Torae:
"No nudging my narrative, fuck whatever fad is in, cause
I am so NY like **550 Madison**"

189 Torae:
"**Neptune & Surf**, murder made the worst, n---as came in
Benzes, left in a hearse"

190 Tragedy Khadafi:
"**Make a right, 40th Ave.**, that's when I smile and laugh"

191 Troy Ave:
"Toilet paper in my porsche 'cause I'm shittin',
94th & Wilmohr in the kitchen"

192 U God:
"You know the thrill, yes it's **Park Hill**, yo we hit 'em with
the hot grits"

193 Westside Gunn:
"Ayo, parked the La Dalat in front of **Guggenheim**, I'm
sellling 2 for 5s, coke swimming, we had to scuba dive"

194 Wiki:
"Take the **A to West 4th**, and I turn south Spring & Sully
all the boys got they work out"

195 Wiki:
"Take the A to West 4th, and I turn south **Spring & Sully**
all the boys got they work out"

196 Wiki:
"Sipping up, **Houston & 6th**, Bruno playing ball, bussin'
ass, dressing fucking fresh like he was playing golf"

197 Wiki:
"Where should we meet? **96th Street, last car on the 3**, peace"

198 Yelawolf:
"1, 2, 3, I'm at the **Chelsea Hotel**, like, Sid and Nancy,
with a knife and two grams of candy"

199 Your Old Droog:
"Dylan Dylan where the hell is Dylan, prolly hiding out on
West 8th & Highlawn"

200 Your Old Droog:
"Who got a raw aura, your style is a horror your style's more
like Laura, and I'm a G, still transfer for the **G, at Lorimer**"

9

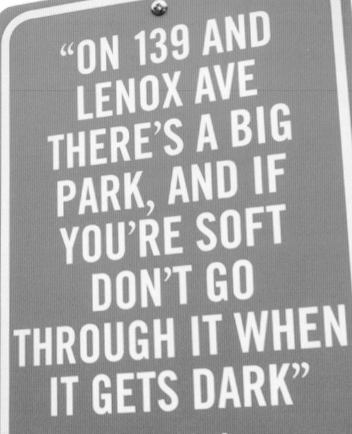

"ON 139 AND LENOX AVE THERE'S A BIG PARK, AND IF YOU'RE SOFT DON'T GO THROUGH IT WHEN IT GETS DARK"

— *Big L*

@TheRapQuotes @TheRapQuotes

139th Street & Lenox Avenue, Harlem, Manhattan

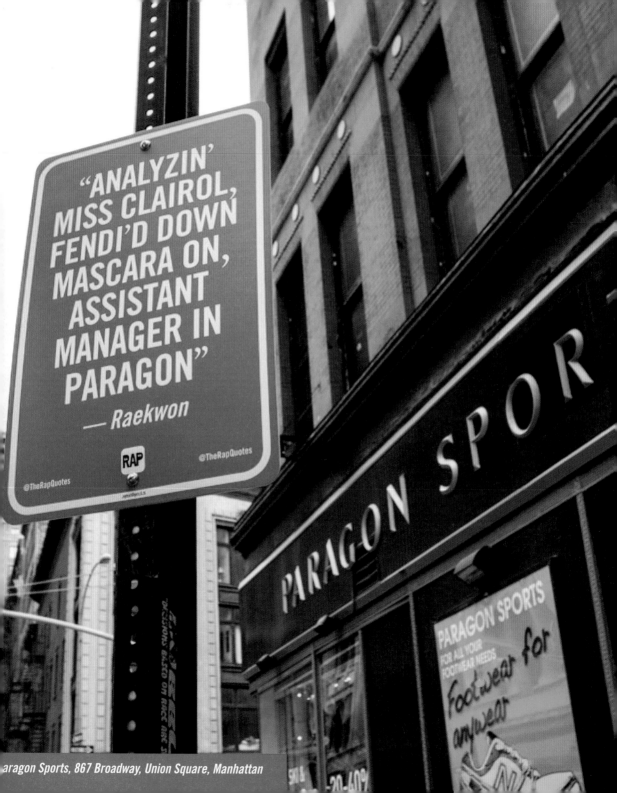

"ANALYZIN' MISS CLAIROL, FENDI'D DOWN MASCARA ON, ASSISTANT MANAGER IN PARAGON"

— Raekwon

aragon Sports, 867 Broadway, Union Square, Manhattan

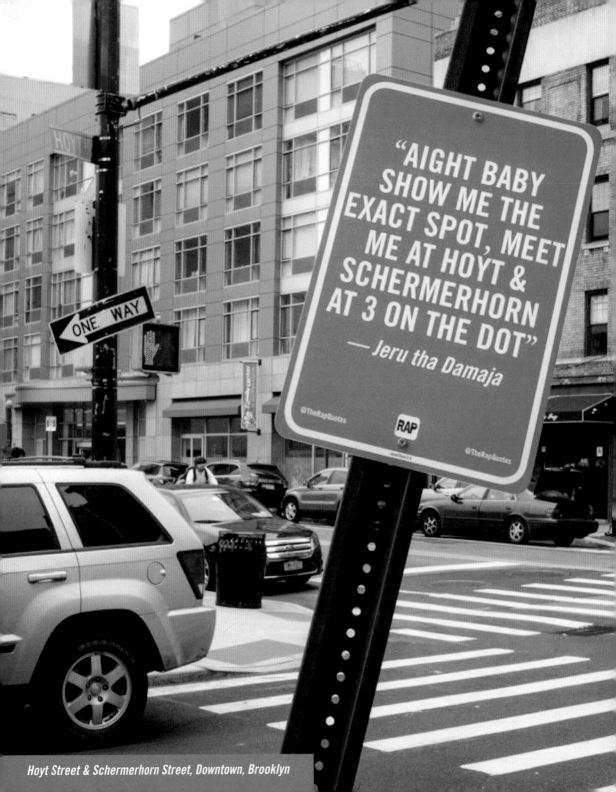

"AIGHT BABY SHOW ME THE EXACT SPOT, MEET ME AT HOYT & SCHERMERHORN AT 3 ON THE DOT"

— Jeru tha Damaja

@TheRapQuotes

RAP

@TheRapQuotes

Hoyt Street & Schermerhorn Street, Downtown, Brooklyn

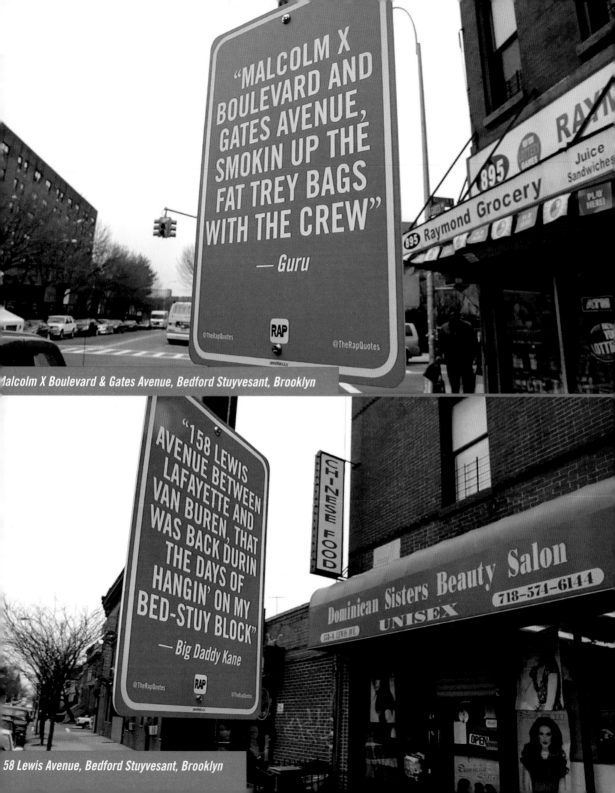

"MALCOLM X BOULEVARD AND GATES AVENUE, SMOKIN UP THE FAT TREY BAGS WITH THE CREW"

— Guru

@TheRapQuotes

RAP

@TheRapQuotes

Malcolm X Boulevard & Gates Avenue, Bedford Stuyvesant, Brooklyn

"158 LEWIS AVENUE BETWEEN LAFAYETTE AND VAN BUREN, THAT WAS BACK DURIN THE DAYS OF HANGIN' ON MY BED-STUY BLOCK"

— Big Daddy Kane

@TheRapQuotes

RAP

158 Lewis Avenue, Bedford Stuyvesant, Brooklyn

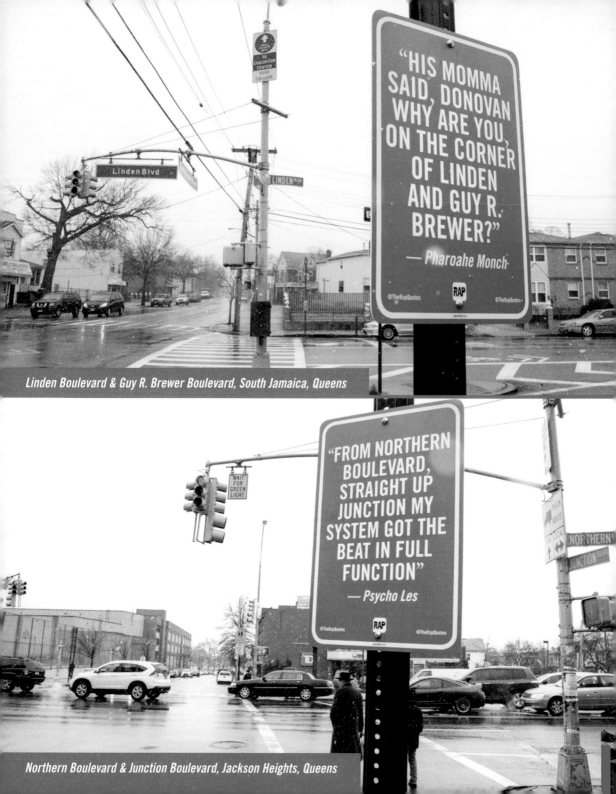

"HIS MOMMA SAID, DONOVAN WHY ARE YOU, ON THE CORNER OF LINDEN AND GUY R. BREWER?"

— *Pharoahe Monch*

RAP

@TheRapQuotes @TheRapQuotes

Linden Boulevard & Guy R. Brewer Boulevard, South Jamaica, Queens

"FROM NORTHERN BOULEVARD, STRAIGHT UP JUNCTION MY SYSTEM GOT THE BEAT IN FULL FUNCTION"

— *Psycho Les*

RAP

@TheRapQuotes @TheRapQuotes

Northern Boulevard & Junction Boulevard, Jackson Heights, Queens

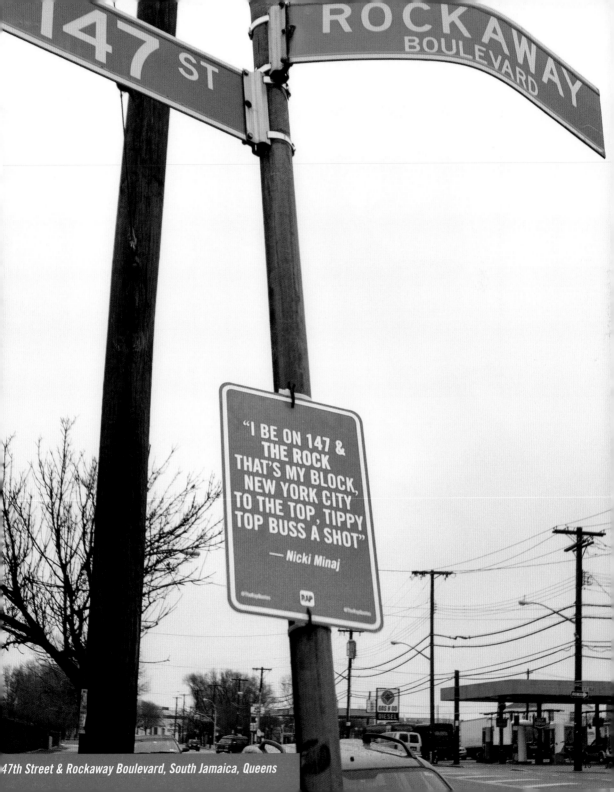

147 ST

ROCKAWAY
BOULEVARD

"I BE ON 147 &
THE ROCK
THAT'S MY BLOCK,
NEW YORK CITY
TO THE TOP, TIPPY
TOP BUSS A SHOT"

— Nicki Minaj

RAP

47th Street & Rockaway Boulevard, South Jamaica, Queens

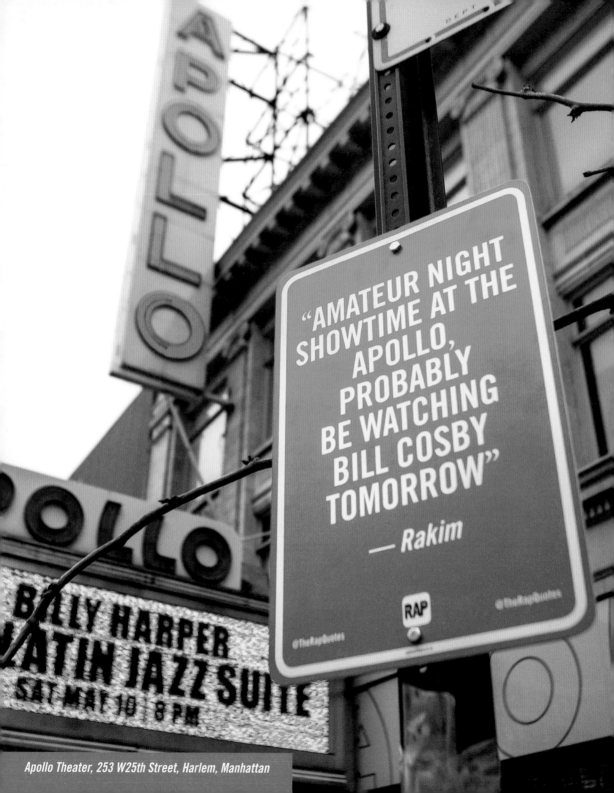

"AMATEUR NIGHT
SHOWTIME AT THE
APOLLO,'
PROBABLY
BE WATCHING
BILL COSBY
TOMORROW"

— *Rakim*

RAP

@TheRapQuotes

@TheRapQuotes

BILLY HARPER
LATIN JAZZ SUITE
SAT MAY 10 8 PM

Apollo Theater, 253 W25th Street, Harlem, Manhattan

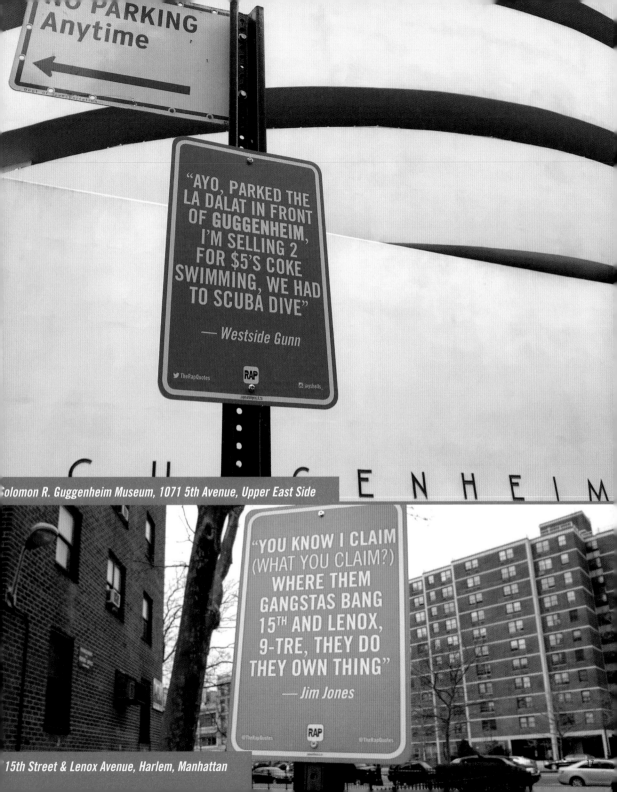

NO PARKING Anytime

"AYO, PARKED THE LA DALAT IN FRONT OF **GUGGENHEIM**, I'M SELLING 2 FOR $5'S COKE SWIMMING, WE HAD TO SCUBA DIVE"

— *Westside Gunn*

TheRapQuotes — **RAP** — jayshells_

Solomon R. Guggenheim Museum, 1071 5th Avenue, Upper East Side

GUGGENHEIM

"YOU KNOW I CLAIM (WHAT YOU CLAIM?) WHERE THEM GANGSTAS BANG 15TH AND LENOX, 9-TRE, THEY DO THEY OWN THING"

— *Jim Jones*

@TheRapQuotes — **RAP** — @TheRapQuotes

15th Street & Lenox Avenue, Harlem, Manhattan

"TO THE HOOK, TO THE EAST, TO BE STUY, BUSHWICK & CANARSIE FARRAGUT, FORT GREENE & MARCY"

— Mos Def

jaysells_ RAP TheRapQuotes

Dodworth Street & Broadway, Brooklyn

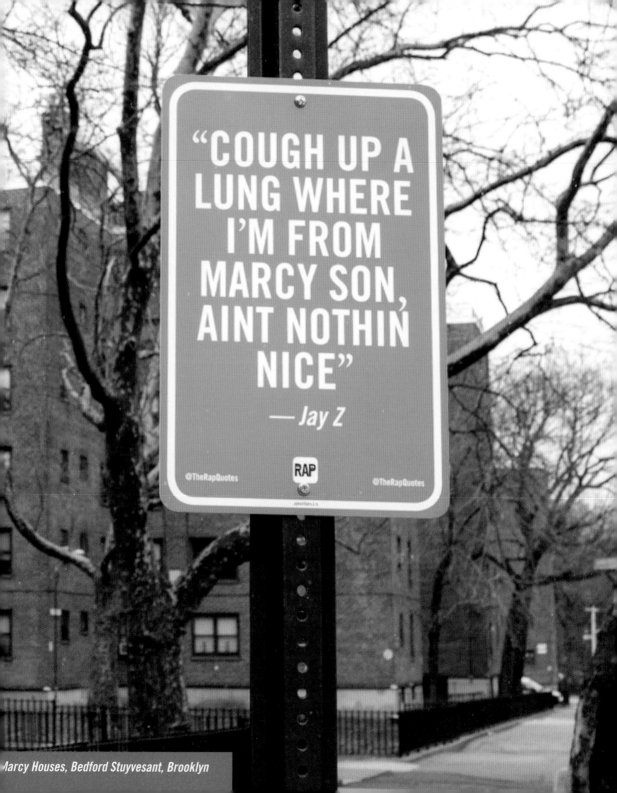

"COUGH UP A LUNG WHERE I'M FROM MARCY SON, AINT NOTHIN NICE"

— Jay Z

@TheRapQuotes

RAP

@TheRapQuotes

Marcy Houses, Bedford Stuyvesant, Brooklyn

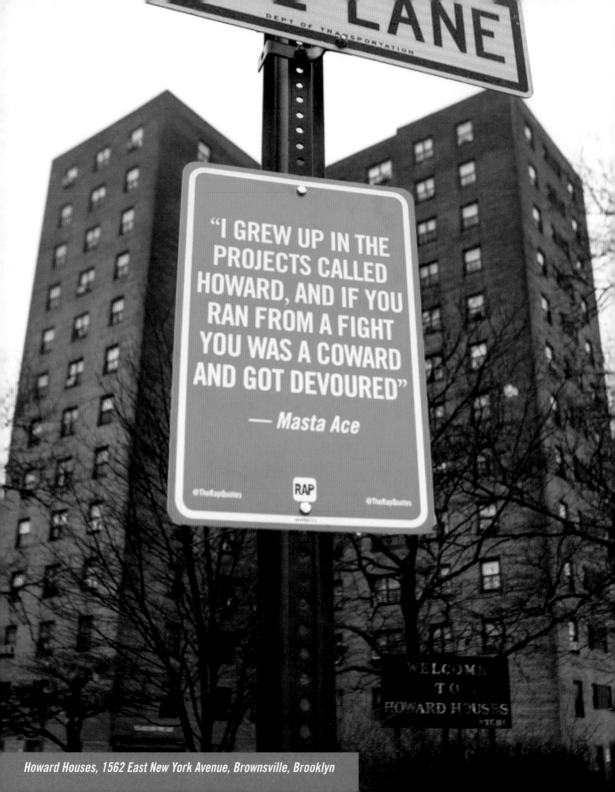

Howard Houses, 1562 East New York Avenue, Brownsville, Brooklyn

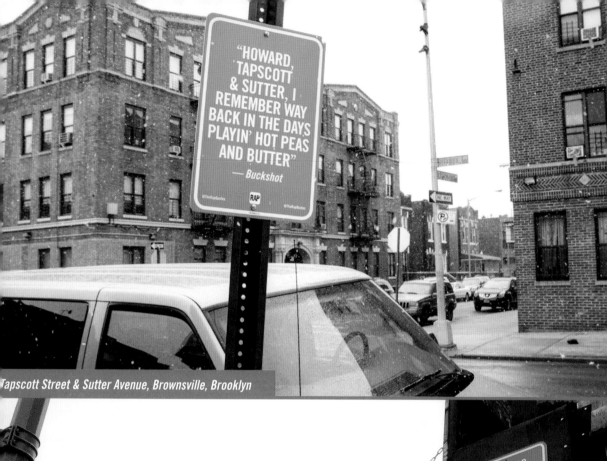

"HOWARD, TAPSCOTT & SUTTER, I REMEMBER WAY BACK IN THE DAYS PLAYIN' HOT PEAS AND BUTTER"

— Buckshot

Tapscott Street & Sutter Avenue, Brownsville, Brooklyn

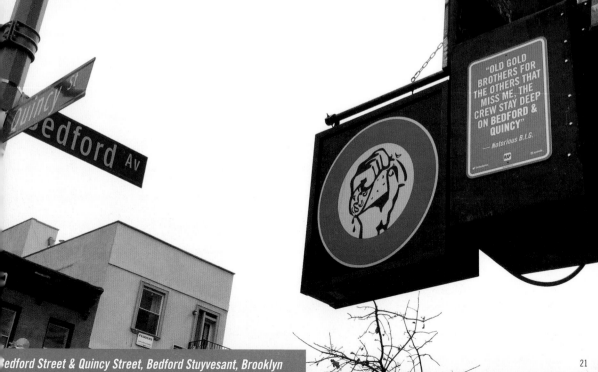

"OLD GOLD BROTHERS FOR THE OTHERS THAT MISS ME, THE CREW STAY DEEP ON BEDFORD & QUINCY"

— Notorious B.I.G.

Bedford Street & Quincy Street, Bedford Stuyvesant, Brooklyn

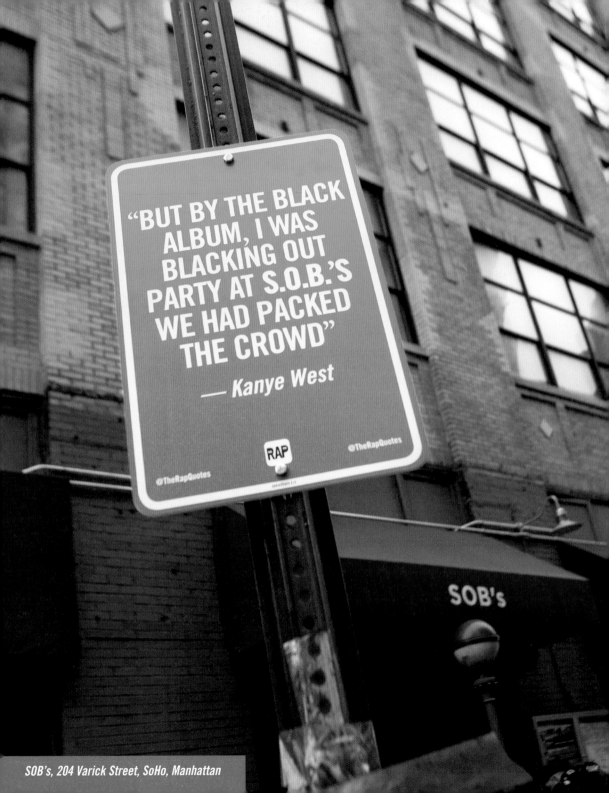

"BUT BY THE BLACK ALBUM, I WAS BLACKING OUT PARTY AT S.O.B.'S WE HAD PACKED THE CROWD"

— Kanye West

SOB's, 204 Varick Street, SoHo, Manhattan

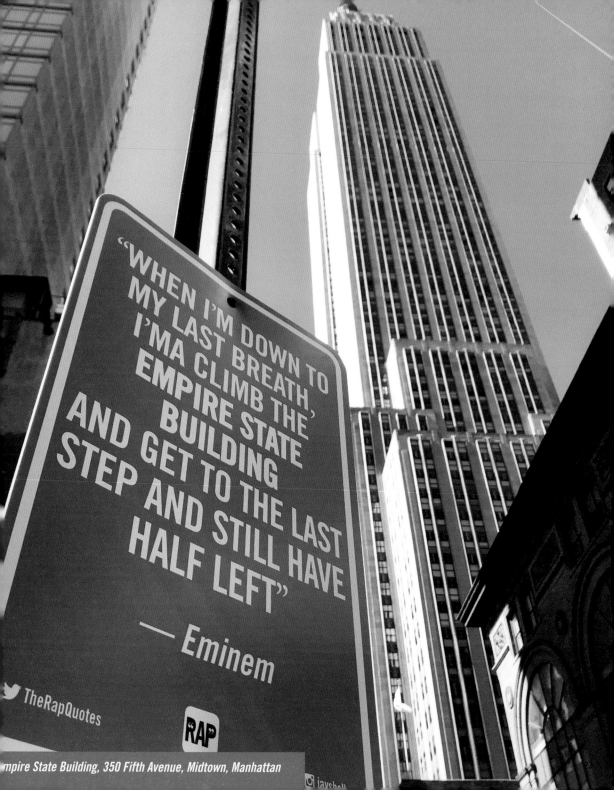

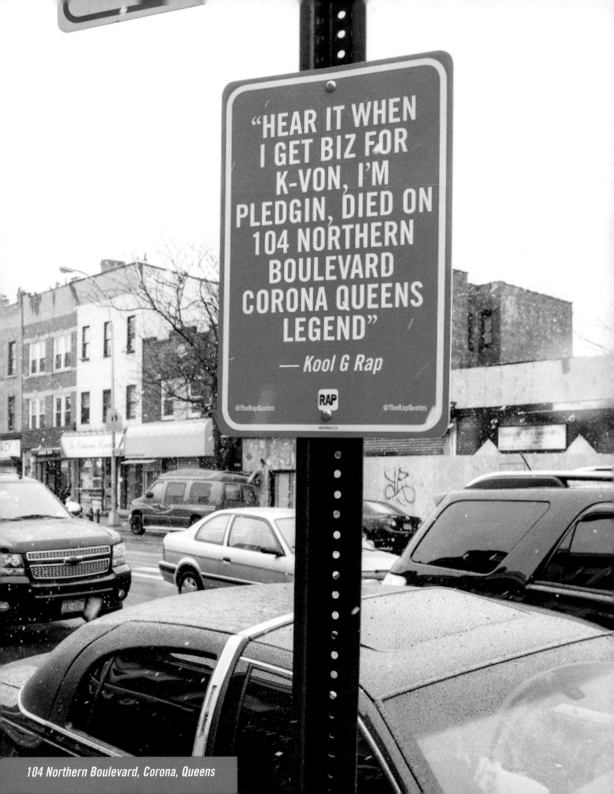

"HEAR IT WHEN I GET BIZ FOR K-VON, I'M PLEDGIN, DIED ON 104 NORTHERN BOULEVARD CORONA QUEENS LEGEND"

— Kool G Rap

104 Northern Boulevard, Corona, Queens

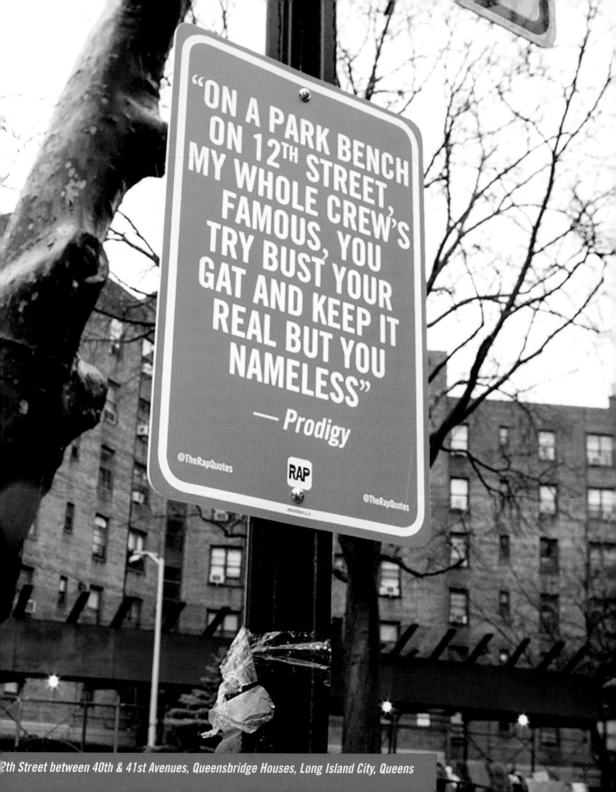

"ON A PARK BENCH ON 12TH STREET, MY WHOLE CREW'S FAMOUS, YOU TRY BUST YOUR GAT AND KEEP IT REAL BUT YOU NAMELESS"

— Prodigy

@TheRapQuotes

RAP

@TheRapQuotes

2th Street between 40th & 41st Avenues, Queensbridge Houses, Long Island City, Queens

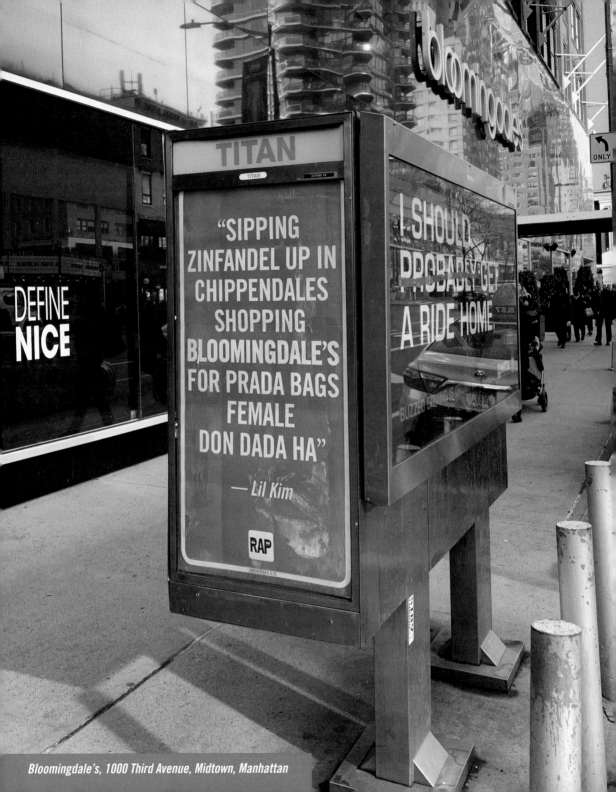

"SIPPING ZINFANDEL UP IN CHIPPENDALES SHOPPING BLOOMINGDALE'S FOR PRADA BAGS FEMALE DON DADA HA"

— Lil Kim

RAP

Bloomingdale's, 1000 Third Avenue, Midtown, Manhattan

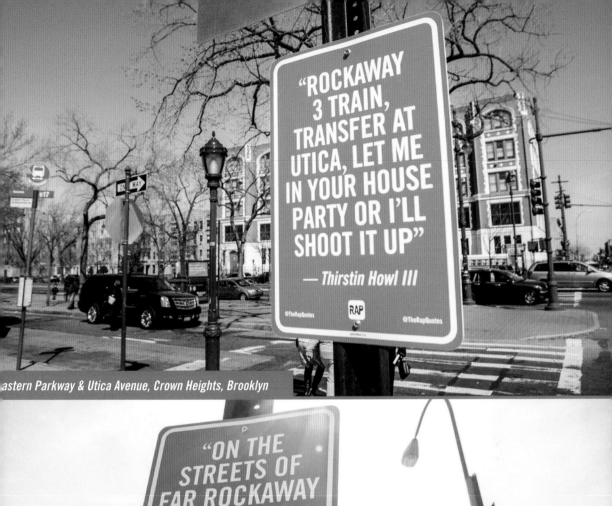

"ROCKAWAY 3 TRAIN, TRANSFER AT UTICA, LET ME IN YOUR HOUSE PARTY OR I'LL SHOOT IT UP"

— Thirstin Howl III

@TheRapQuotes RAP @TheRapQuotes

astern Parkway & Utica Avenue, Crown Heights, Brooklyn

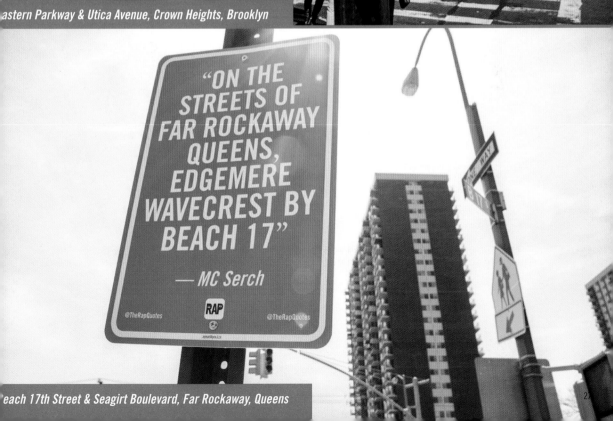

"ON THE STREETS OF FAR ROCKAWAY QUEENS, EDGEMERE WAVECREST BY BEACH 17"

— MC Serch

@TheRapQuotes RAP @TheRapQuotes

each 17th Street & Seagirt Boulevard, Far Rockaway, Queens

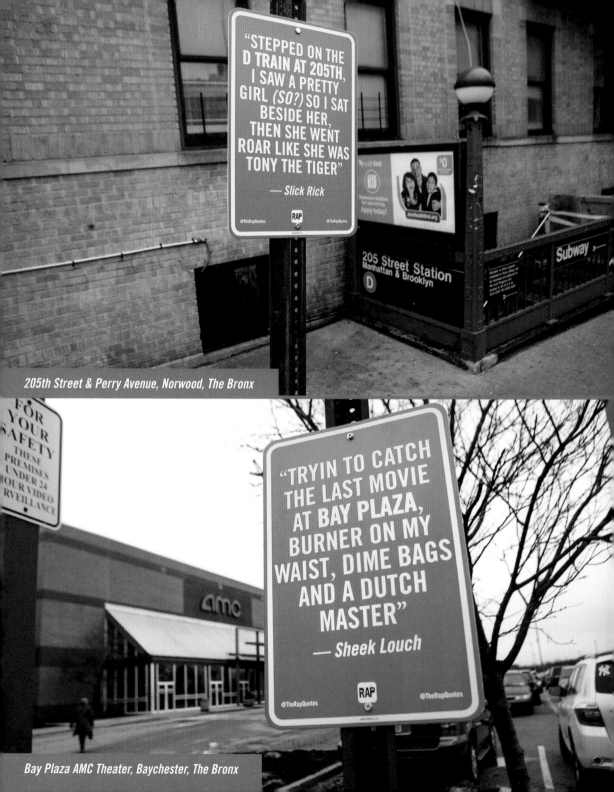

"STEPPED ON THE D TRAIN AT 205TH, I SAW A PRETTY GIRL *(SO?)* SO I SAT BESIDE HER, THEN SHE WENT ROAR LIKE SHE WAS TONY THE TIGER"

— *Slick Rick*

205 Street Station
Manhattan & Brooklyn
D

Subway

205th Street & Perry Avenue, Norwood, The Bronx

FOR YOUR SAFETY
THESE PREMISES UNDER 24 HOUR VIDEO SURVEILLANCE

amc

"TRYIN TO CATCH THE LAST MOVIE AT BAY PLAZA, BURNER ON MY WAIST, DIME BAGS AND A DUTCH MASTER"

— *Sheek Louch*

RAP
@TheRapQuotes @TheRapQuotes

Bay Plaza AMC Theater, Baychester, The Bronx

"PATTERSON PROJECTS IS WHERE I REST, BUT I CLAIM THE WHOLE PLANET CUZ IT'S MINE GODDAMNIT"

— A.G.

RAP

@TheRapQuotes @TheRapQuotes

"ALL DAY, WILDIN FREESTYLIN IN THE HALLWAYS BROADWAY AIN'T GOT MORE DRAMA THAN WATSON OFF OF COLGATE"

— *Big Pun*

RAP

@TheRapQuotes @TheRapQuotes

Watson Avenue & Colgate Avenue, Soundview, The Bronx

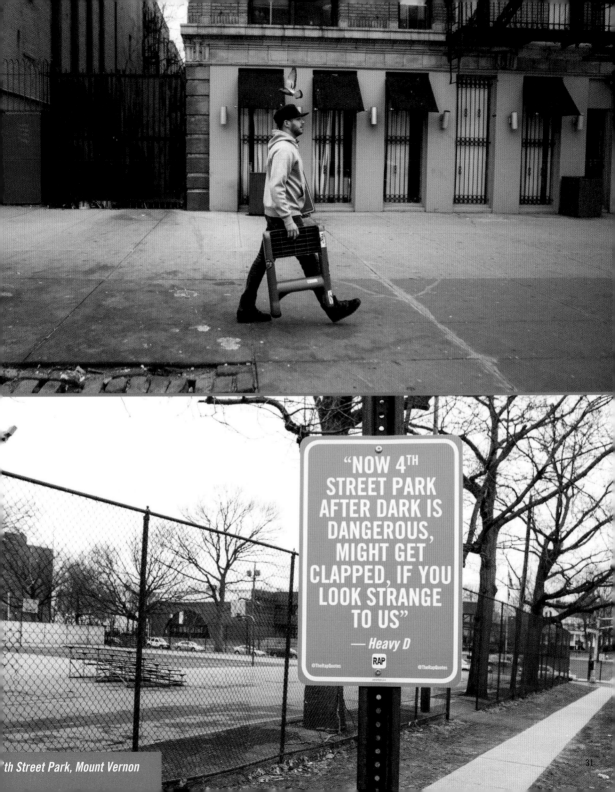

"NOW 4TH STREET PARK AFTER DARK IS DANGEROUS, MIGHT GET CLAPPED, IF YOU LOOK STRANGE TO US"

— Heavy D

th Street Park, Mount Vernon

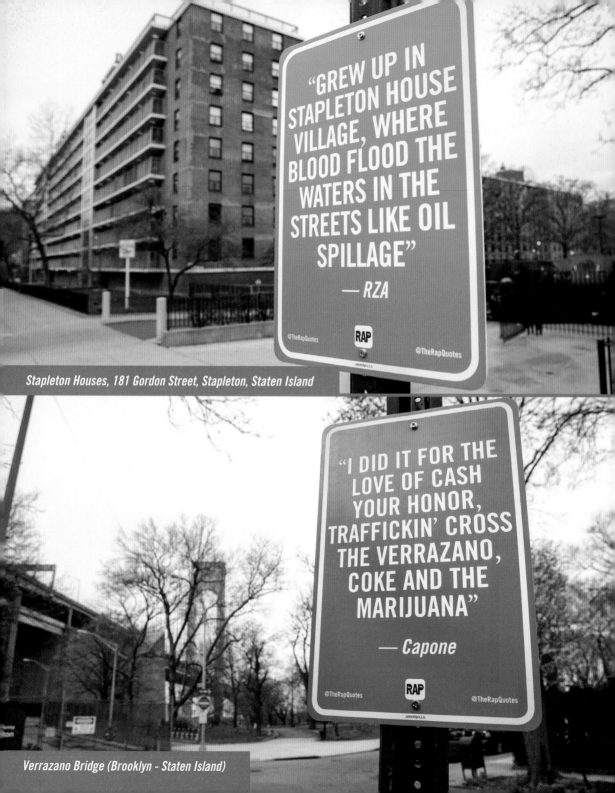

"GREW UP IN STAPLETON HOUSE VILLAGE, WHERE BLOOD FLOOD THE WATERS IN THE STREETS LIKE OIL SPILLAGE"

— RZA

@TheRapQuotes RAP @TheRapQuotes

Stapleton Houses, 181 Gordon Street, Stapleton, Staten Island

"I DID IT FOR THE LOVE OF CASH YOUR HONOR, TRAFFICKIN' CROSS THE VERRAZANO, COKE AND THE MARIJUANA"

— Capone

@TheRapQuotes RAP @TheRapQuotes

Verrazano Bridge (Brooklyn - Staten Island)

"PARK HILL
STATEN ISLAND
SEAL, ROCK THE
REEL, TO REEL,
WE HIGH HILLS
DEEP"

— Cappadonna

@TheRapQuotes

RAP

@TheRapQuotes

JAYSHELLS

" In Philadelphia, before there were beats, there was street art.

Graffiti, then called wall writing, exploded in Philadelphia in the mid-'60s, before the culture blossomed in New York. At the time, folks in town were listening to Motown acts like the Supremes, or local groups like the Delfonics. But as the years progressed and listeners embraced funk and later hip hop, Philly made a habit of keeping up, while innovating along the way.

It's often said that since Philly is just 90 miles away from New York, the genre easily traveled south. Philadelphians were active in hip hop's earliest years, like Lady B who became one of the first women to drop a rap single in 1979. The early indie hip hop label Pop Art was established in town that same year, attracting Queens legends Roxanne Shante and MC Shan to its roster. West Philly rapper Schoolly D, widely viewed as the father of gangster rap, released his first album in 1985.

Plus, Philly quickly developed a reputation for fierce DJs. DJ Cash Money won a trifecta of titles back-to-back, first winning the New Music Seminar DJ Battle in 1987, then taking the DMC American Mixing Championship and World DJ Championship in 1988. According to the magazine Wax Poetics, he performed so well at the DMC World Championship that the tournament banned him. Back home, his main rival was DJ Jazzy Jeff, who aside from being a pioneer in his own right, won rap's first ever Grammy with Will "The Fresh Prince" Smith for "Parents Just Don't Understand."

The nation got to see the Belmont Plateau, a scenic West Philly park, in DJ Jazzy Jeff and The Fresh Prince's video for "Summertime," another hip hop classic. The Plateau holds a special place in local hip hop lore. When Jay Shells visited the city in 2014, he posted not one, but two signs there.

The Philly edition of The Rap Quotes spans not only a large distance (the two farthest signs were some 14 miles apart), but also generations of local hip hop. From Bahamadia to Black Thought, to Beanie Sigel to Quilly, the fashions changed but the local devotion to rugged, battle-ready spittas persisted.

Freeway rhyming about an incarcerated friend became a sign near the city's prison complex. Jay Electronica's memories from his time in Philly from the song "Exhibit C," landed on the intersection of 23rd and Tasker, but that sign mentions several locations around town. A Neef line about drinking rum punch on South Street got a sign too. Many quotes are shout-outs to neighborhood spots and corners, but look more closely: Slices of Philadelphia life reveal themselves. "

CASSIE OWENS

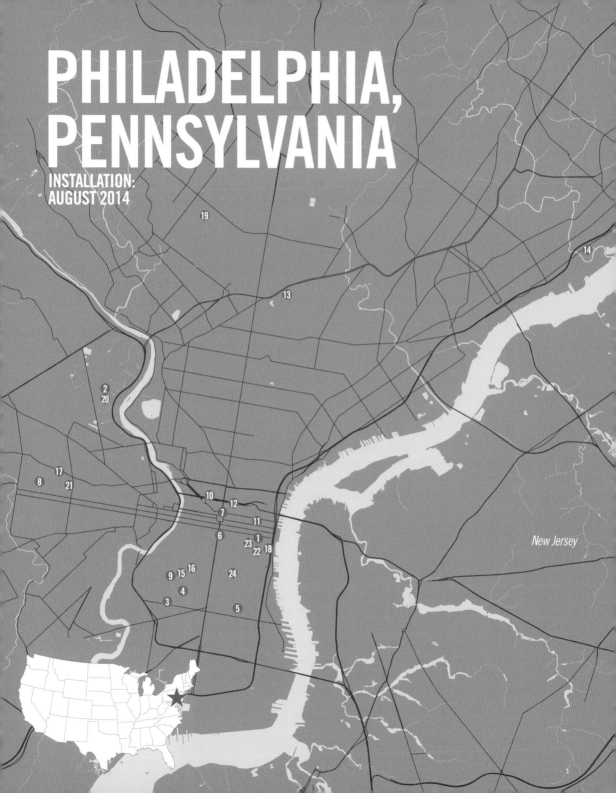

PHILADELPHIA, PENNSYLVANIA

**INSTALLATION:
AUGUST 2014**

New Jersey

1 **Action Bronson**
"Then I went and had a cheesesteak from **Ishkabibble's** hit the sizzle, control the whip with one arm like Richard Kimble"

2 **Bahamadia**
"Raps way back at **the Plat** with super bad disco, used to do the freak to Patty Duke and Giggalo"

3 **Beanie Sigel**
"Got in junk with Passyunk, **Wilson Park** and them, other jects different sets started sparkin 'em"

4 **Beanie Sigel**
"You like: 'naw, Beans?' same n---a from **21st & Sigel Street**, when it's beef people let them desert eagle speak"

5 **Black Thought**
"Limitless when I bless the mic with speak, dialect never weak, y'all n---as know Tariq, from **7th & Snyder Ave.** got the flavor you need"

6 **Black Thought**
"My cousins Jarrod and Todd, was livin' type large got caught, then blast crashed off on **Broad & Lombard**"

7 **Black Thought**
"So I'm meditatin' on how to maintain, stepped off at **City Hall** into the rain"

8 **Black Thought**
"Spark shit, them n---as try to talk shit, we hit 'em like the **El at 60th & Market**"

9 **Black Thought**
"Whatever Ave. transform to the war path, pure wrath from North down to **24th & Task**"

10 **Cassidy**
"I said: 'Well, we leavin' and I took her to the top floor of the **Four Seasons** and got right"

11 **Danny Brown**
"Used to have that crack like the **Liberty Bell**, but now I hit chicks with lips like Estelle"

12 **Dark Lo**
"Pace n---as like Roy Hibbert or cased up, shackled up on the bus, **13th & Filbert**"

13 **EST (3 Times Dope)**
"Stompin' out rock & roll from **7th & Wingohocking** to Jerome to Kerbaugh Street is how the rhymes get with funky beats"

14 **Freeway**
"Cause my man Rell fightin' a body on **State Road,** where it's so cold, Rockin' his blues I roll with the ROC"

15 **Jay Electronica**
"While y'all debated who the truth was like Jews & Christians, I was on Cecil B, Broad Street, Master, North Philly, South Philly, **23rd & Tasker**"

16 **Meek Mill**
"She text: 'Where I'm comin' to?' He text back '**1022, Woodstock in North Philly,** take the E-Way to the zoo'"

17 **Myself**
"Always hanging 'round, living off of **Vine,** as in West Philly, **56th Street**"

18 **Neef**
"Down **The Reef on South Street,** eating rasta pasta drinking rum punch"

19 **Quilly Millz**
"All about that green Paul Pierce, Sam Cassell here, this our block, **Haines & Morton,** you can't sell here"

20 **The Fresh Prince**
"Back in Philly we be out in the park, a place called **the Plateau** is where everybody goes"

21 **Tone Trump**
"I'm from a good cloth, see I'm a hood boss, **54th & murder Market** that's my hood, dog"

22 **Will Smith**
"Get the van from Rock then call up **Ishkabibble's,** Jim's and Pat's, and tell 'em we need cheese steaks for like 300 cats"

23 **Will Smith**
"Get the van from Rock then call up Ishkabibble's, **Jim's** and Pat's, and tell 'em we need cheese steaks for like 300 cats"

24 **Will Smith**
"Get the van from Rock then call up Ishkabibble's, Jim's and **Pat's,** and tell 'em we need cheese steaks for like 300 cats"

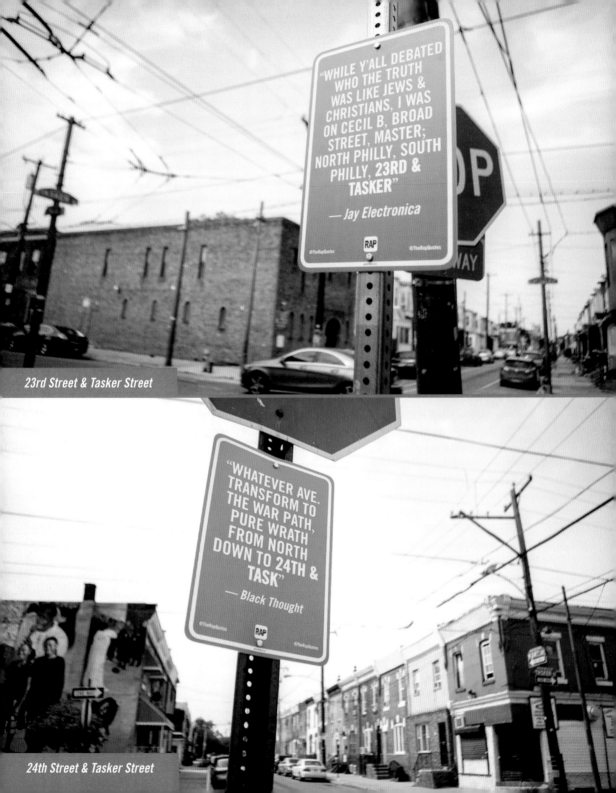

"WHILE Y'ALL DEBATED WHO THE TRUTH WAS LIKE JEWS & CHRISTIANS, I WAS ON CECIL B. BROAD STREET, MASTER; NORTH PHILLY, SOUTH PHILLY, 23RD & TASKER"

— Jay Electronica

23rd Street & Tasker Street

"WHATEVER AVE. TRANSFORM TO THE WAR PATH, PURE WRATH FROM NORTH DOWN TO 24TH & TASK"

— Black Thought

24th Street & Tasker Street

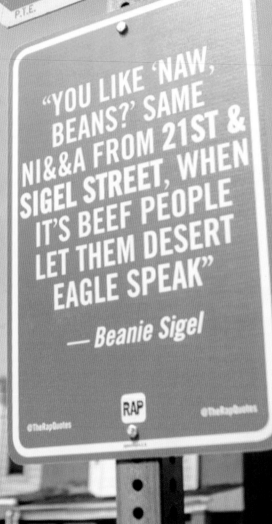

"YOU LIKE 'NAW, BEANS?' SAME NI&&A FROM 21ST & SIGEL STREET, WHEN IT'S BEEF PEOPLE LET THEM DESERT EAGLE SPEAK"

— Beanie Sigel

RAP

@TheRapQuotes @TheRapQuotes

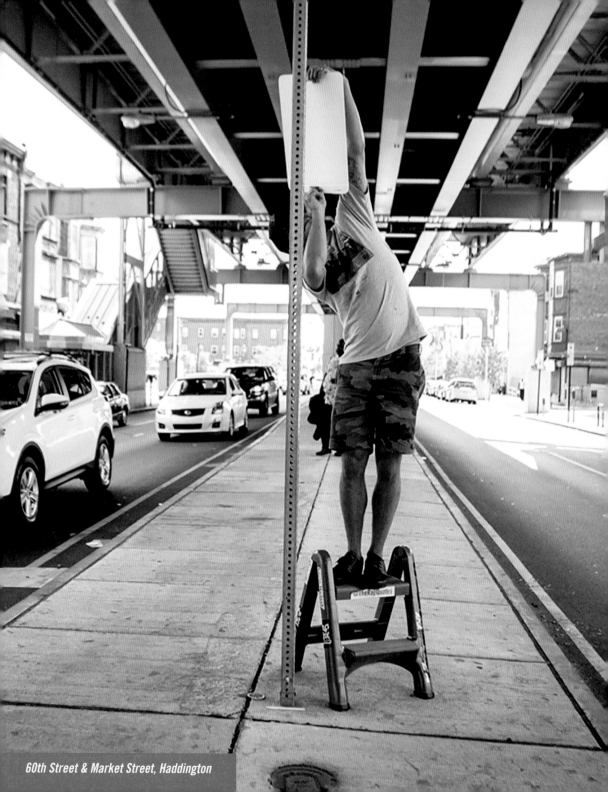

60th Street & Market Street, Haddington

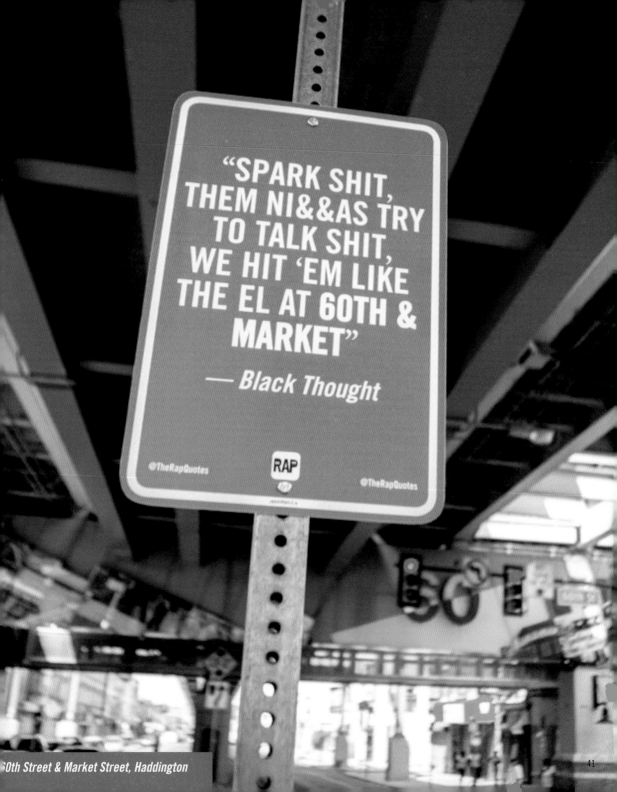

"SPARK SHIT, THEM NI&&AS TRY TO TALK SHIT, WE HIT 'EM LIKE THE EL AT 60TH & MARKET"

— Black Thought

@TheRapQuotes RAP @TheRapQuotes

60th Street & Market Street, Haddington

41

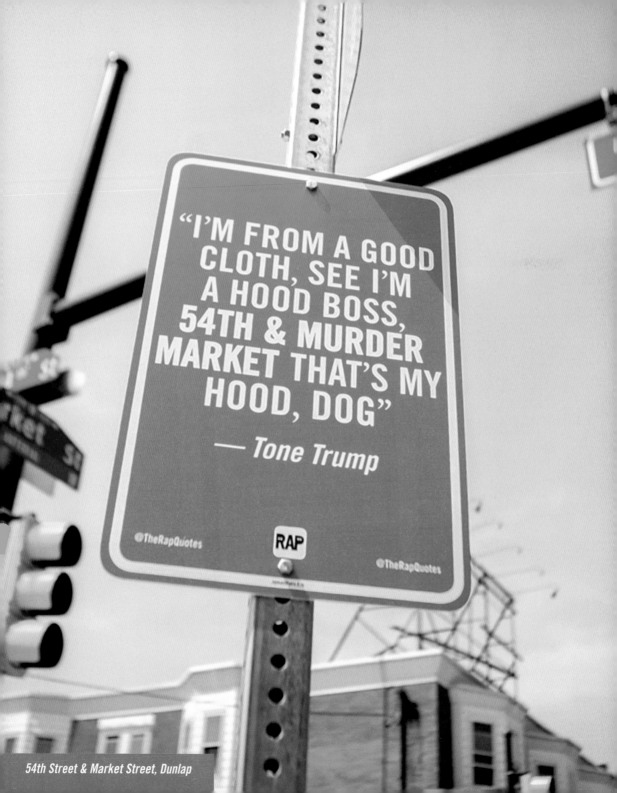

"I'M FROM A GOOD CLOTH, SEE I'M A HOOD BOSS, 54TH & MURDER MARKET THAT'S MY HOOD, DOG"

— Tone Trump

@TheRapQuotes RAP @TheRapQuotes

54th Street & Market Street, Dunlap

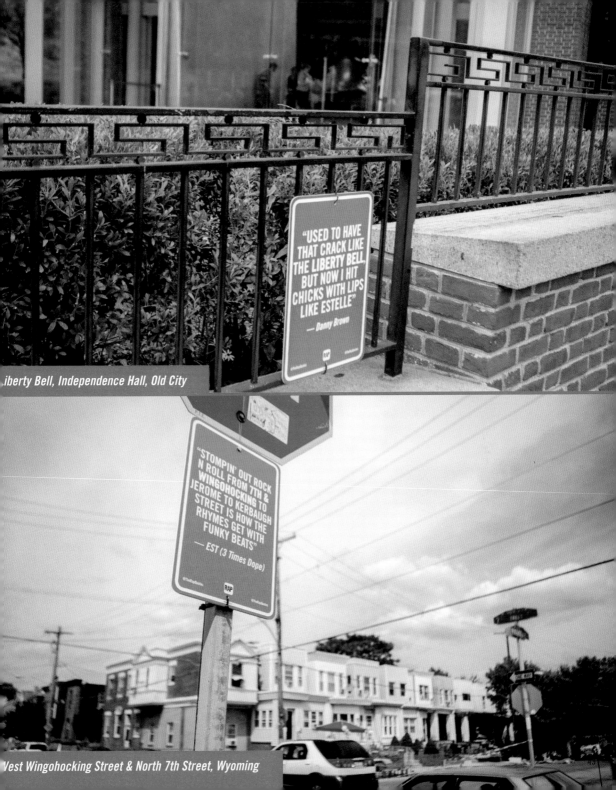

"USED TO HAVE
THAT CRACK LIKE
THE LIBERTY BELL,
BUT NOW I HIT
CHICKS WITH LIPS
LIKE ESTELLE"

— Danny Brown

Liberty Bell, Independence Hall, Old City

"STOMPIN' OUT ROCK
N ROLL FROM 7TH &
WINGOHOCKING TO
JEROME TO KERBAUGH
STREET IS HOW THE
RHYMES GET WITH
FUNKY BEATS"

— EST (3 Times Dope)

West Wingohocking Street & North 7th Street, Wyoming

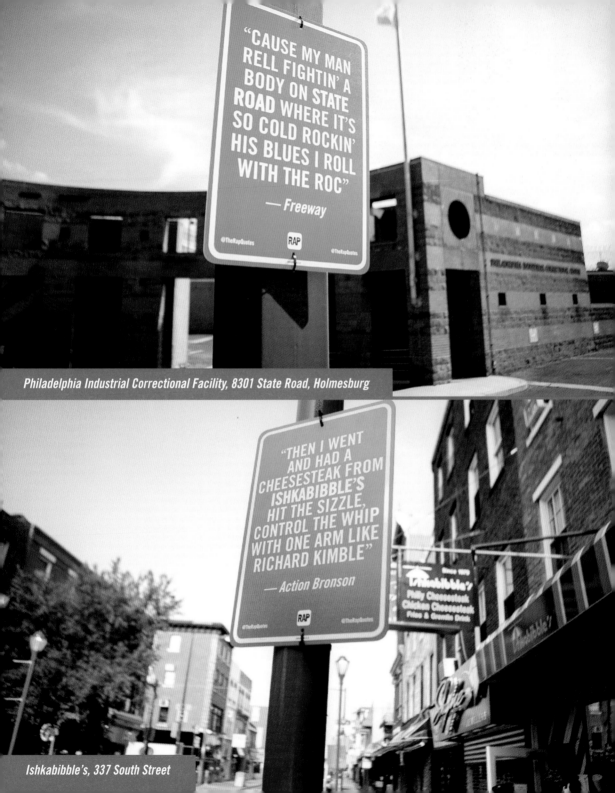

"CAUSE MY MAN RELL FIGHTIN' A BODY ON STATE ROAD WHERE IT'S SO COLD ROCKIN' HIS BLUES I ROLL WITH THE ROC"

— Freeway

@TheRapQuotes RAP @TheRapQuotes

Philadelphia Industrial Correctional Facility, 8301 State Road, Holmesburg

"THEN I WENT AND HAD A CHEESESTEAK FROM ISHKABIBBLE'S HIT THE SIZZLE, CONTROL THE WHIP WITH ONE ARM LIKE RICHARD KIMBLE"

— Action Bronson

@TheRapQuotes RAP @TheRapQuotes

Ishkabibble's, 337 South Street

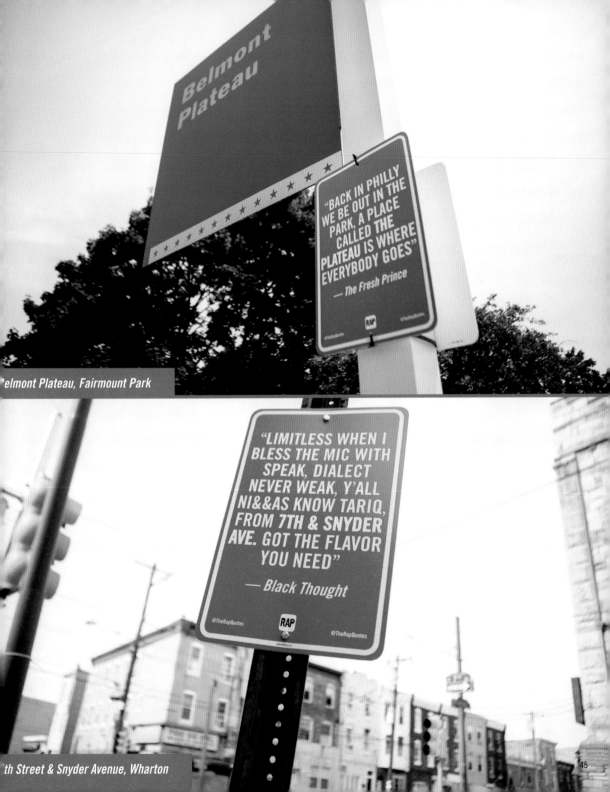

"BACK IN PHILLY WE BE OUT IN THE PARK, A PLACE CALLED THE PLATEAU IS WHERE EVERYBODY GOES"

— *The Fresh Prince*

elmont Plateau, Fairmount Park

"LIMITLESS WHEN I BLESS THE MIC WITH SPEAK, DIALECT NEVER WEAK, Y'ALL NI&&AS KNOW TARIQ, FROM 7TH & SNYDER AVE. GOT THE FLAVOR YOU NEED"

— *Black Thought*

@TheRapQuotes @TheRapQuotes

th Street & Snyder Avenue, Wharton

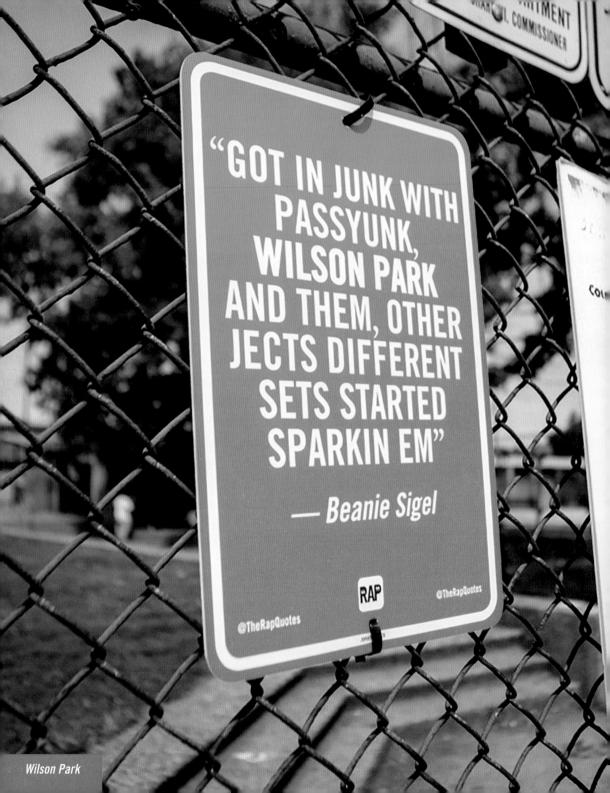

"GOT IN JUNK WITH PASSYUNK, WILSON PARK AND THEM, OTHER JECTS DIFFERENT SETS STARTED SPARKIN EM"

— Beanie Sigel

@TheRapQuotes

RAP

@TheRapQuotes

Wilson Park

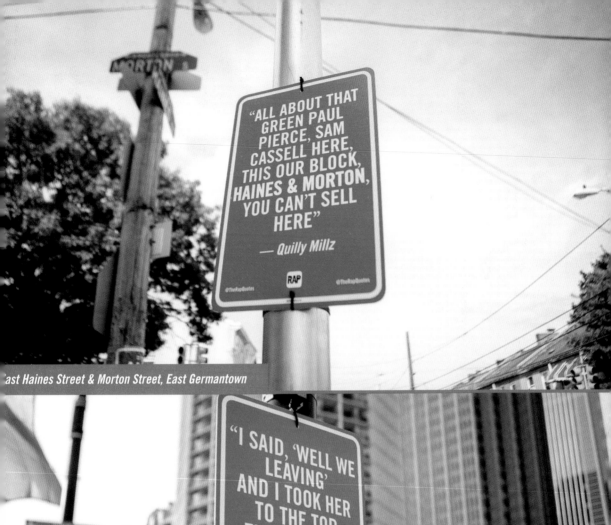

"ALL ABOUT THAT GREEN PAUL PIERCE, SAM CASSELL HERE, THIS OUR BLOCK, HAINES & MORTON, YOU CAN'T SELL HERE"

— *Quilly Millz*

RAP
@TheRapQuotes @TheRapQuotes

East Haines Street & Morton Street, East Germantown

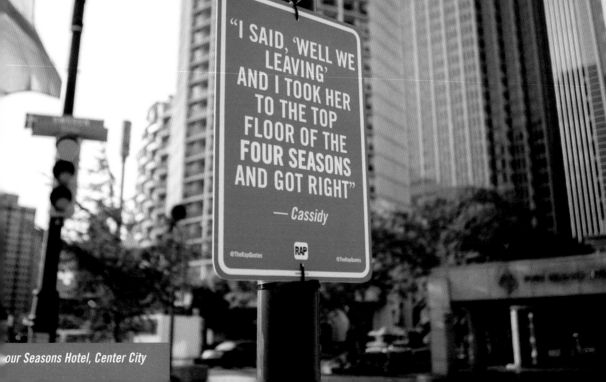

"I SAID, 'WELL WE LEAVING' AND I TOOK HER TO THE TOP FLOOR OF THE FOUR SEASONS AND GOT RIGHT"

— *Cassidy*

RAP
@TheRapQuotes @TheRapQuotes

Four Seasons Hotel, Center City

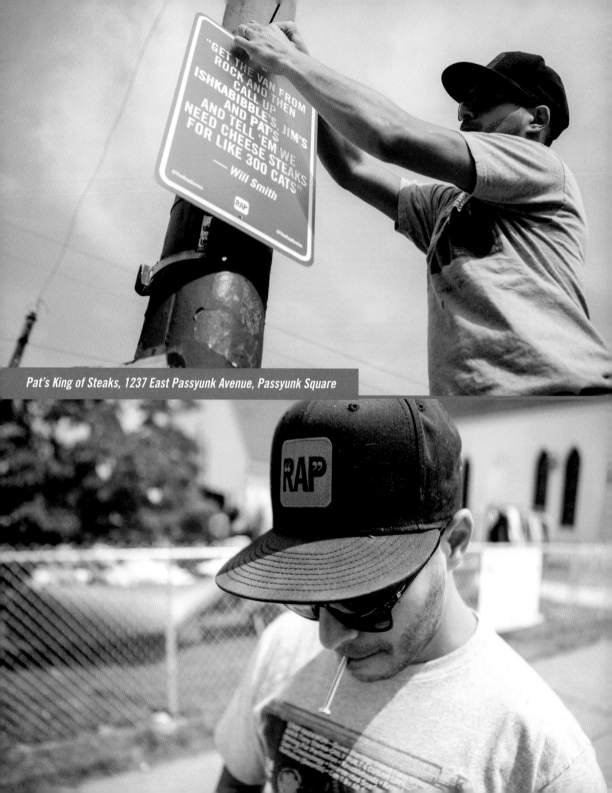

"GET THE VAN FROM
ROCK AND THEN
CALL UP
ISHKABIBBLE'S JIM'S
AND PAT'S
AND TELL 'EM WE
NEED CHEESE STEAKS
FOR LIKE 300 CATS"
— Will Smith

RAP

Pat's King of Steaks, 1237 East Passyunk Avenue, Passyunk Square

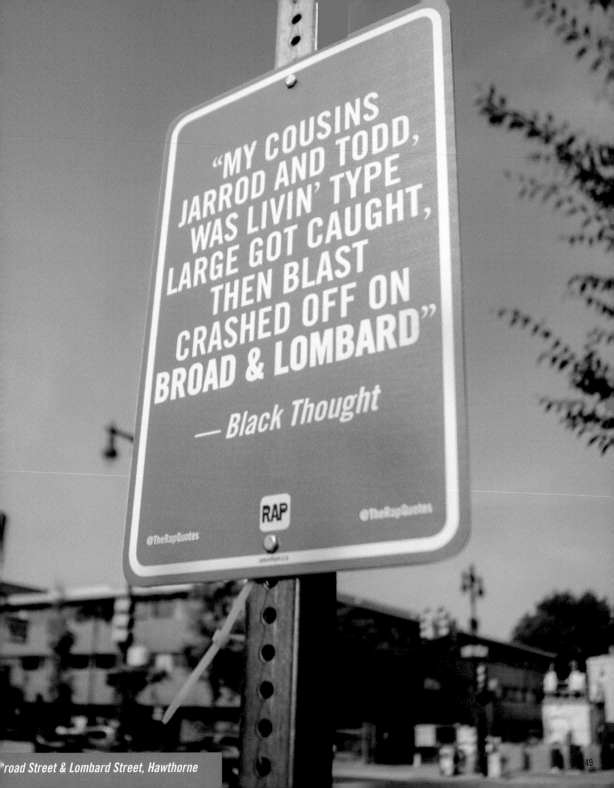

"MY COUSINS JARROD AND TODD, WAS LIVIN' TYPE LARGE GOT CAUGHT, THEN BLAST CRASHED OFF ON BROAD & LOMBARD"

— *Black Thought*

RAP

@TheRapQuotes

@TheRapQuotes

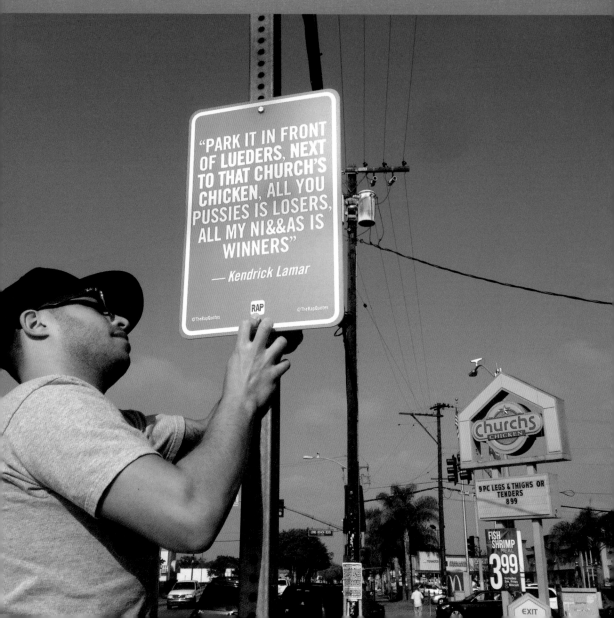

LOS ANGELES, CALIFORNIA

"

Nowadays, when I tell people that I was raised in Calabasas, they immediately think of hip hop—which, trust me, is something I never saw coming. Thanks to Kanye West, Dr. Dre and Drake, it's become an epicenter of sorts—a meme for decadence and Klass, spelled with a "K" like each of the Kardashian daughters' first names. Though my high school's student parking lot was filled with Mercedes Benz and Range Rovers, my parents were middle class, a fact easily noticed when my used 1993 Mercury Capri pulled into the driveway every morning before class. And in the late '90s, my adoration for hip hop stood out just as much.

Feeling financially out of place, it was easy for me to gravitate towards rap music in the late '80s, even though my affluent classmates focused on bubblegum pop and hard rock. The city was informally dubbed "Cala-blackless," so when looking for a culture completely removed from my surroundings, nothing seemed further away than hip hop. Not only did I totally engulf myself in the genre, restlessly studying the pages of The Source and rewinding every Kool Moe Dee tape I could afford with my allowance, I started to rap myself, eventually getting a management deal with Ice-T's Rhyme Syndicate, and then landing an Interscope record deal during college. And from an early age, I respected the art form, could recite any fact you found the need to quiz me on and was always incredibly nice on the mic, but what I lacked more than anything, was a like-minded community.

And that's why Jay's work speaks so loudly to me. You see, I may have only lived 20 minutes from Lewis St. and E. 21st, but when I heard Warren G. mention that spot on "Regulate," I couldn't have felt further away. But what was most important was that I at least knew there was a world outside of my own, living and breathing outside of my privilege. I know it's a cliche at this point to call rap music "the CNN of the streets," but it truly is. I lived in a San Fernando Valley bubble, but thanks to MC Eiht, The Alkaholiks, Pharcyde, Ice Cube, Rodney O & Joe Cooley, King Tee and Ras Kass, I knew I'd be more open-minded than my fellow students when it came time for college. I coincidentally attended USC in Los Angeles, a university settled in an area often mentioned in the songs I obsessed over in my teens and much more familiar with rap music.

And location has always meant so much when it comes to West Coast rap. I remember my awe when passing the V.I.P. Records I had heard Snoop mention and I'm sure kids have the same reaction nowadays when they pass the Fairfax Avenue that guys like Tyler The Creator commonly reference. Where you're from has always held so much weight in rap music, and the ability to create landmarks, especially for a kid like me from the suburbs, was ideal when understanding that these lyrics were real, not just works of violence glorifying fiction. And now an artist treats these locations with the importance they deserve.

Jay's work pays tribute to the surroundings that inspired some of the greatest songs of all-time, while acknowledging how important they are. So no matter what city you live in, from an isolated farm in Kansas to a suburb Drake hasn't yet decided to live in, you'll know something more important exists out there. And when you get there, there just might be a Jay Shells sign.

"

JENSEN KARP

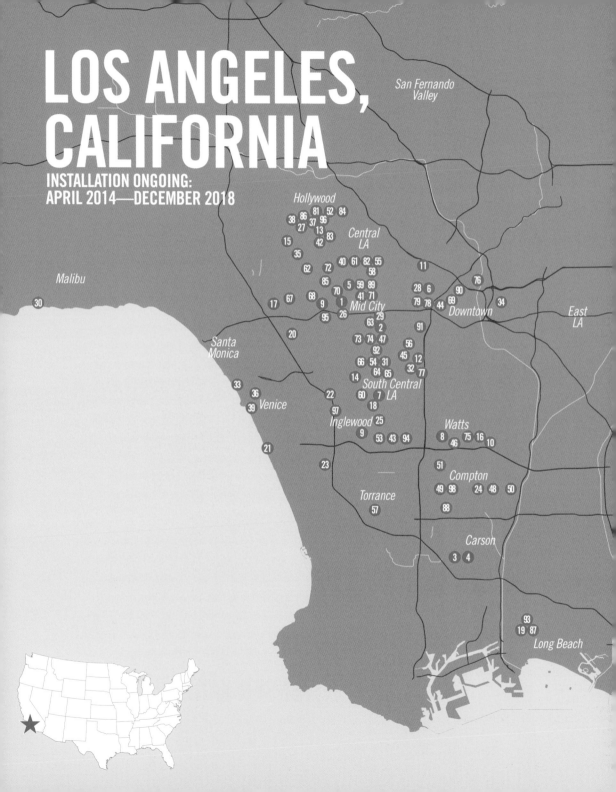

LOS ANGELES, CALIFORNIA

INSTALLATION ONGOING:
APRIL 2014—DECEMBER 2018

2Mex:
"Grew up in Mid-City California 1981, **Sycamore Avenue right off La Brea and Washington**"

2Pac:
"Out for everything they owe, remember K-Day? Weekends, **Crenshaw, MLK**"

Ab Soul:
"**Avalon & Del Amo** cross streets baby, baby mamas strapping babies in car seats"

Ab Soul:
"I'm strolling on **Del Amo Boulevard towards the Arco** to get another Black 'n Mild, my lungs must look like charcoal"

Action Bronson:
"Doin all the drugs off of **Pico & La Brea**, peace to Kings English, sticky green fingers"

Aloe Blacc:
"Goodbye **12th Street & Hoover**, we won't miss you, now sirens and gang banging teens ain't the issue"

AMG:
"**76 & Crenshaw** was the locale, I used to smoke out between my vocals"

Bad Lucc:
"Where you from homeboy? Watts city **106 & Towne** exact"

Bad Lucc:
"Now what it is with that, born in Ingles I did **Osage & Lennox** 'til 6 moms got in some shit"

Bambu:
"Hope I made my city proud 'cause I get down for y'all, from **Jordan's old soul food on Wilmington** to **Tommy's on Rampart**, we living in a city with no pity"

Bambu:
"Hope I made my city proud 'cause I get down for y'all from **Jordan's old soul food on Wilmington** to **Tommy's on Rampart**, we living in a city with no pity"

Blu:
"Since I was a yella coming out of Centinela, **Vernon & Vermont** I had them goldies in a fish tank, bad on cassette tape"

Bun B:
"Bun B the OG like '95 Air Max, neon green outta **Flight Club off Fairfax**"

Chace Infinite:
"My birthplace, my home and I'll be **buried on Prairie**, cross the street from where I was born in LA."

Childish Gambino:
"Get the check, deposit the shit at **Maxfield**, feelin' my self, I don't even need an ex-pill"

Crooked I:
"Got street power from the **Watts Towers** to Howard Hughes, how would you become me, I don't do what you cowards do"

Crooked I:
"Charcoal Murcielago, parked oh at the **Wilshire Margot**, Arco, hoes gas me up, way faster than the car go"

Damani:
"**104th & 10th Ave.** is where my love for the wood was birthed"

Daz Dillinger:
"N---as got to trippin' and I thought I heard it, so I went to the hood on **20th & Myrtle**"

20 Defari:
"Defari cold guy with a style that's polished like **Sepulveda & Venice car wash**, the street star spot"

21 Defari:
"It's hella hot, we pull up to **Dockweiler**, the scene is so lovely it make me wanna holla"

22 Defari:
"Push down **La Tijera**, give a fuck who's starin', hop on the **405** with a prior like Aaron"

23 Diamond D:
"I'm sippin on piña colada, **two blocks off La Cienega, at the Ramada**"

24 DJ Quik:
"Now I'm about to take you back to '84 when I was 14 kicking back in the trees, west side if you please & **436 West Spruce** was the spot"

25 DJ Quik:
"So how 'bout instead of doin 106th & Park, we do **108th & Crenshaw**, after dark"

26 Dom Kennedy:
"I'm just tryna win for 'em slide up **La Brea** baby, hit the **10** for 'em"

27 Dom Kennedy:
"Got one dog, I think that shit is a beagle, she dress like one of them girls at **Fred Segal**"

28 Double K:
"We makin' dope like **Hoover & Pico**, move slow be polite and everything'll be alright"

29 Dr. Dre:
"No concern as I make a **left turn on the Shaw off of Jefferson**, feeling awfully naked at the U-turn"

30 Drake:
"And man shout my n---a Game he just rolled through, eatin' crab out in **Malibu at Nobu**"

31 Eazy E:
"Ridin' on **Slauson lookin for Crenshaw**, turned down the sound to ditch the law"

32 Eazy E:
"See a bitch I used to fuck bust a left on Slauson at a light on **Hoover** make a right all the way down to **49th**"

33 Evidence:
"Got my CW, the Mike Buff model, to the **W Station 26**, the first at the beach"

34 Evidence:
"I did a show in Chicago on the first, now I'm back in LA like **Chicago & 1st**"

35 Evidence:
"Straight out L.A.—never lied, born in the **same hospital Biggie Smalls died**"

36 Evidence:
"Weed's legal in Cali, **421 Rose** is where my people tally, count the amount, eighths half the weight over the limits an ounce, over the counter, I'm out"

37 Fashawn:
"No need for petro, I grab a buck and hop the Metro, to **Melrose & Fairfax** for kicks that's retro"

38 Fatlip:
"Looking right cause my shit is tight, blazing blunts to city lights on **Sunset & Crescent Heights**"

39 Frank Ocean:
"Humble old me had to flex for the folks, down in **Muscle Beach** pumping iron and bone"

40 Ghostface Killah:
"Move, every script's like Miramax, smash the big boy, totalled it, **Wilshire & Fairfax**"

41 Hittman:
"A high-post ho, a perfect way for me to keep dough, huh, have her sellin' ass on **Bronson Ave. & Pico**"

42 Hodgy Beats:
"Catch me on the block, **Fairfax & Oakwood**, rolling up sipping on the finest alcohol"

43 Ice Cube:
"I never forgot **Van Ness & Imperial**, look at my life, Ice Cube is a miracle"

44 Ice Cube:
"Let's go to the hood and fuck with the haters, then to the **Staples Center**, hang with the lakers"

45 Ice T:
"We boned down **Vernon made right on Normandie**, left on Florence, jettin' through the E.T.G's"

46 Jay Rock:
"Hitting donuts in the intersection, **105 exit Central**, n---a eastside Watts nothing residential"

47 K-Dee:
"Banked a quick left 'cause there's more of them down on **Crenshaw & Vernon**, watch the curb while I'm turnin'"

48 Kendrick Lamar:
"So now I'm down **Rosecrans** in a Caravan, **passin' Alameda** my gas meter in need of a pump"

49 Kendrick Lamar:
"Can't let the government tell me how my future looking, I'm on **Rosecrans & Central** trying to duck the central bookings"

50 Kendrick lamar:
"Park it **in front of Lueders, next to that Church's Chicken**, all you pussies is losers, all my n---as is winners"

51 Kendrick lamar:
"I met her at this house party on **El Segundo & Central**, she had the credentials of strippers in Atlanta"

52 Krondon:
"Crack your spine, caught out the hood on **Sunset & Vine**"

53 Kurupt:
"I've been all over from **Crenshaw & Imperial** to 108th, I'm sure Mack got my back"

54 Kurupt:
"Why don't you bring your ass on over to **Crenshaw & Slauson**, take a walk through the hood and we up to no good."

55 Lord Zen:
"All sprayed on the walls from the schools of South Bay, cafes Long Beach to the **El Rey**"

56 Luckyiam PSC:
"Little Miss Natasha Novinsky, shipped off to Hollywood, wound up at the **Snooty Fox**, right up off of Arlington, or was it Western?"

57 Luckyiam PSC:
"Mama went to school to be a nurse and bring funds, into the household like pops did while she was taking classes, at **El Camino College**"

58 Luckyiam PSC 3:
"I went to **John Burroughs** first, girly was a meanie, cheated on me with a dude that used to go to Uni"

59 Lupe Fiasco:
"Lu see (Lucy) like **La Brea & Pico**, with binoculars on my peephole"

60 Mack 10:
"The landmarks in the hood is legendary, the fabulous **Forum**, the court and the library"

61 MF Doom:
"The key, plucked it off the mayor, chucked it in the ol' **tar pit off La Brea**, player"

62 Murs:
"On **3rd & La Cienega**, can't front I was into her she offered me a blunt, damn I wish I smoked Indica"

63 Murs:
"Don't be scared of Crenshaw, the Slauson Super Mall or **Earlez Hot Dogs**, man you gotta do it y'all."

64 Nipsey Hussle:
"**60th & 10th** cable with the chip, 12 gauge behind the door plastic where you sit, I told 'em I would do it, talk a lot of shit"

65 Nipsey Hussle:
"**59th & 5th** at my granny's house, Uncle Reggie spilling Schlitz on my granny's couch, the lesson was never go the addict route"

66 Nipsey Hussle:
"They gettin packed out if n---as try fade with us, **Crenshaw & Slauson**, true story, Zo play the drums"

67 Notorious B.I.G.:
"Met a bitch at the **Versace store**, said she suck it 'til I ain't got no more, only in L.A."

68 Phil da Agony:
"They got n---as in California, that will greet you off the corners off of **Crescent Heights & Horner**"

69 Phil the Agony:
"Playboy dimes in the shower at the tower, downtown off of **9th & Flower**, one block east of Figueroa, in a Eddie Bauer"

70 Rakaa (Iriscience):
"I learned a nickel cost more than a dime before I learned to rhyme, **Crenshaw & Venice**, St. Charles is more specific, Pico & Fairfax the Ethiopian District"

71 Rakaa (Iriscience):
"I learned a nickel cost more than a dime before I learned to rhyme, Crenshaw & Venice, St. Charles is more specific, **Pico & Fairfax** the Ethiopian District"

72 Rakaa (Iriscience):
"In L.A. the Writer's bench was **Fairfax & Olympic**, at Carl's on the block that Ethiopians kick it"

73 Rakaa (Iriscience):
"Playing Chess in **Leimert Park**, the elders showed me the wild wild west is treacherous as Kool Moe Dee"

74 Ras Kass:
"Platinum cuts from Q on **Crenshaw & Leimert**, so what's cracking folks doing the most"

75 Ras Kass:
"**99th & McKinley**, born and raised n---a, this west coast is in me"

76 Ras Kass:
"'Cause never know maybe, they might wind up at **429 Bauchet** locked away, plus can't keep the booty calls waiting"

77 Schoolboy Q:
"On **51st & Fig**, grew up about 10 minutes from the real Ricky"

78 Sick Jacken:
"Born into **Union & 17th**, out the womb in the '70s, repping lost angels through the musical melodies"

79 Sick Jacken:
"The melody's dark, cause of the death medley brought and caused by **Toberman Park,** the 17th block"

81 Sir Menelik:
"A hustler has to mack in fresh gear, my choice of Rolls Royce and a duplex location up at **Sunset & La Brea**"

82 Slug:
"Wrecked the rental on Santa Monica Boulevard, I was headed to the **El Rey** to slap a security guard"

83 Smoke DZA:
"I'm smokin' dope in front of **Dope on Fairfax**, jet life n---a, these Lear raps"

84 Snoop Dogg:
"Run it down the line, **Sunset & Vine**, blew a half a zip by the Hollywood sign"

85 Snoop Dogg:
"Rollin' down **Fairfax**, just left the Nico, **bust a left turn on Pico**"

86 Snoop Dogg:
"Gotta see the bishop, he got me some gator shoes, I'm rollin' to Hollywood, I'm doing the **House of Blues**"

87 Snoop Dogg:
"Yeah, **King Park** was the location, and the bigga G that was my destination"

88 Tash:
"But needless to say, I kept lookin', I found her, right on the corner of **Central & Alondra**"

89 The Game:
"You know I love you like cooked food, I'm a good dude, let's hit the **Roscoe's on Pico**, I'm in a hood mood"

90 Thes One:
"You know me at the graveyard shift, gettin' spliffed, we can take it downtown like **Figueroa & 5th**"

91 Thes One:
"I eat at **Chano's** & La Barca, not Taco Bell, and if your not from the city then you should probably bail"

92 Too $hort:
"Player, this pimp don't lie, how many porn stars you know that went to **Crenshaw High**?"

93 Warren G:
"So I hooks a left on **2-1 and Lewis**, some brothers shooting dice so I said: 'let's do this'"

94 WC:
"Where you at? **Western & Imperial**, It's the pure west coast coming out your stereo"

95 Xzibit:
"Down **La Cienega** to bust a **left on Venice**, where you can find me and mines"

96 Y.O. (UNI):
"Say what up to my man Katrell, at **Joyrich off of Spaulding & Melrose**"

97 Y.O. (UNI):
"No longer about the crease and cuffs, the first spot that we hit is this **Randy's Donuts**"

98 YG:
"N---as ain't beefing with a hamburger, I'm on **Rosecrans n---a, at Tam's Burgers**"

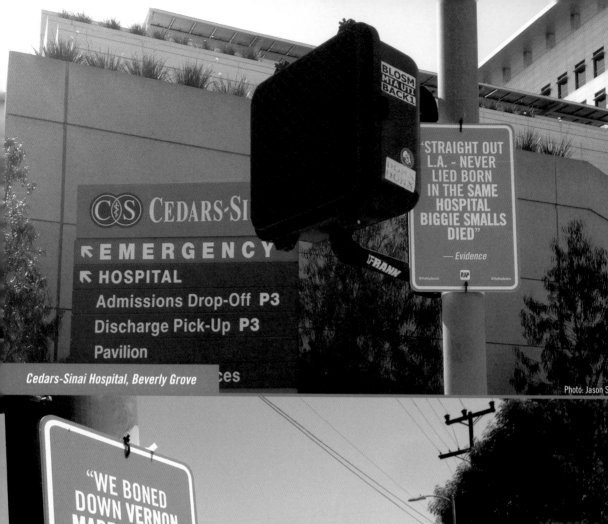

"STRAIGHT OUT L.A. - NEVER LIED BORN IN THE SAME HOSPITAL BIGGIE SMALLS DIED"

— *Evidence*

Cedars-Sinai Hospital, Beverly Grove

Photo: Jason S

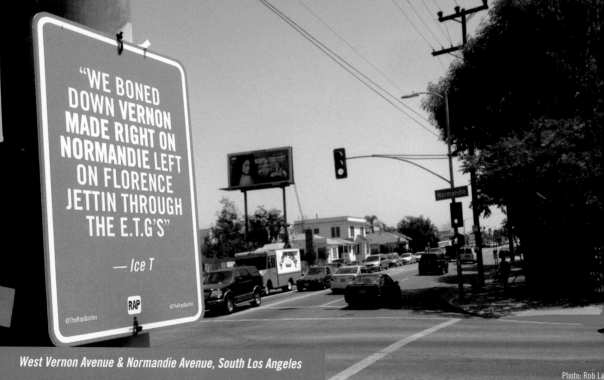

"WE BONED DOWN VERNON MADE RIGHT ON NORMANDIE LEFT ON FLORENCE JETTIN THROUGH THE E.T.G'S"

— *Ice T*

@TheRapQuotes @TheRapQuotes

West Vernon Avenue & Normandie Avenue, South Los Angeles

Photo: Rob La

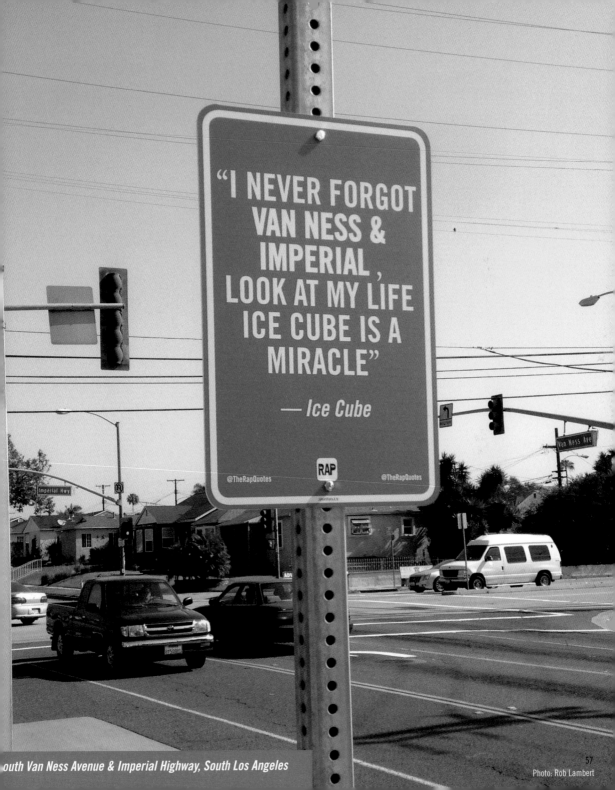

"I NEVER FORGOT VAN NESS & IMPERIAL, LOOK AT MY LIFE ICE CUBE IS A MIRACLE"

— Ice Cube

@TheRapQuotes RAP @TheRapQuotes

outh Van Ness Avenue & Imperial Highway, South Los Angeles

Photo: Rob Lambert

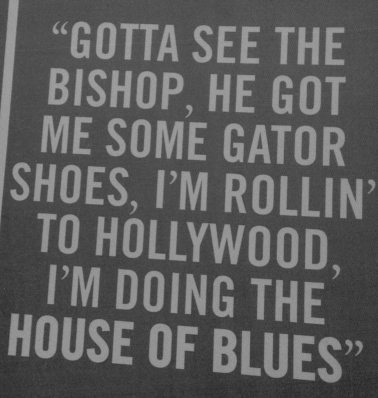

"GOTTA SEE THE BISHOP, HE GOT ME SOME GATOR SHOES, I'M ROLLIN' TO HOLLYWOOD, I'M DOING THE HOUSE OF BLUES"

— Snoop Dogg

@TheRapQuotes

@TheRapQuotes

House of Blues, Sunset Strip

"ON 51ST & FIG GREW UP ABOUT 10 MINUTES FROM THE REAL RICKY"

— Schoolboy Q

RAP
@TheRapQuotes
@TheRapQuotes

West 51st Street & South Figueroa Street, South Los Angeles

Photo: Rob Lambert

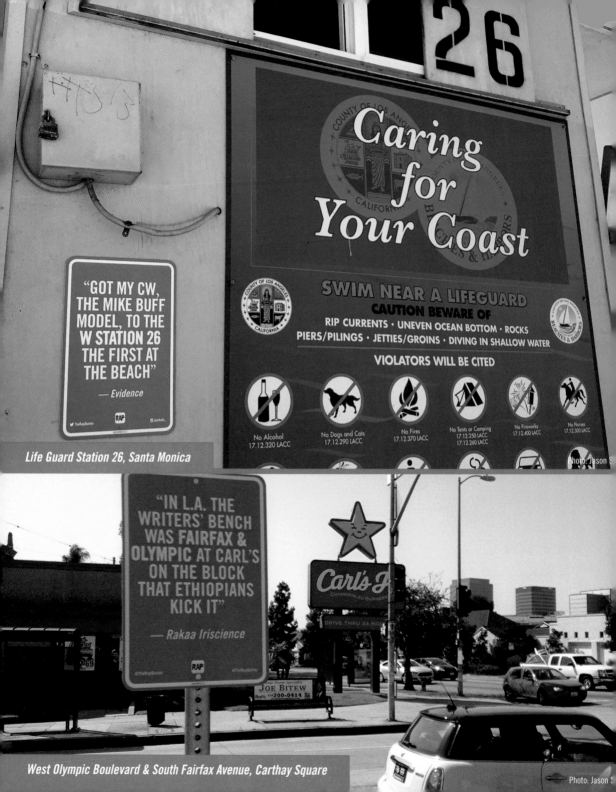

"GOT MY CW,
THE MIKE BUFF
MODEL, TO THE
W STATION 26
THE FIRST AT
THE BEACH"

— *Evidence*

Life Guard Station 26, Santa Monica

"IN L.A. THE
WRITERS' BENCH
WAS FAIRFAX &
OLYMPIC AT CARL'S
ON THE BLOCK
THAT ETHIOPIANS
KICK IT"

— *Rakaa Iriscience*

West Olympic Boulevard & South Fairfax Avenue, Carthay Square

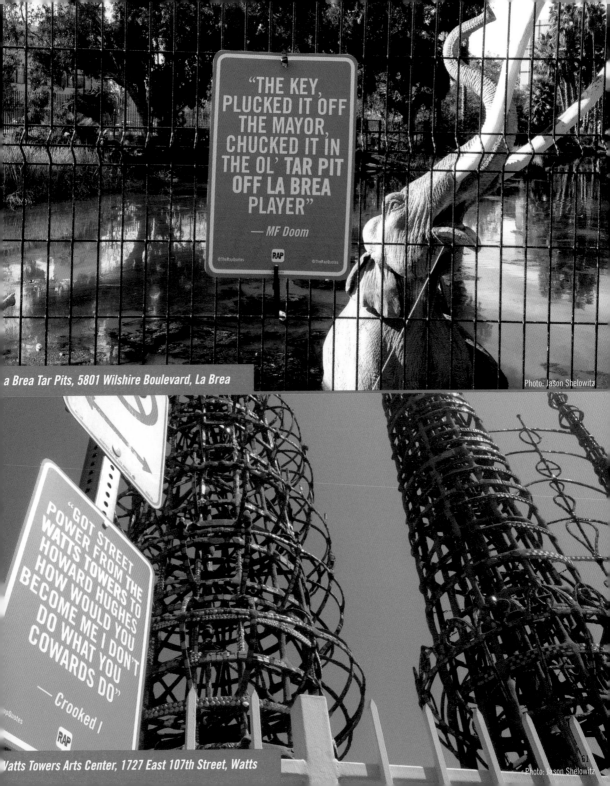

"THE KEY,
PLUCKED IT OFF
THE MAYOR,
CHUCKED IT IN
THE OL' TAR PIT
OFF LA BREA
PLAYER"

— MF Doom

a Brea Tar Pits, 5801 Wilshire Boulevard, La Brea

Photo: Jason Shelowitz

"GOT STREET
POWER FROM THE
WATTS TOWERS TO
HOWARD HUGHES
HOW WOULD YOU
BECOME ME I DON'T
DO WHAT YOU
COWARDS DO"

— Crooked I

Vatts Towers Arts Center, 1727 East 107th Street, Watts

Photo: Jason Shelowitz

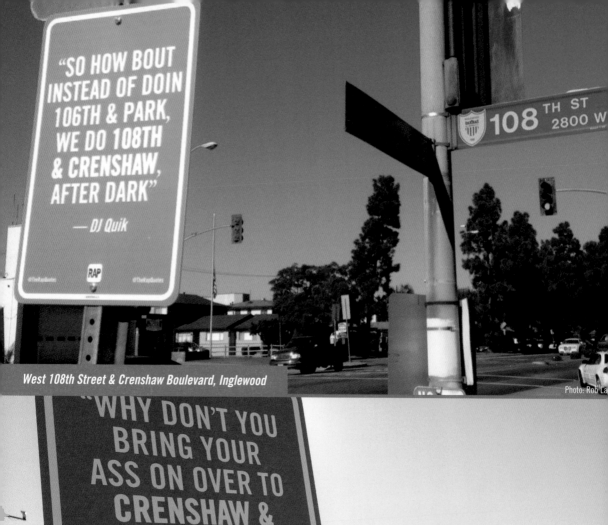

"SO HOW BOUT INSTEAD OF DOIN 106TH & PARK, WE DO 108TH & CRENSHAW, AFTER DARK"

— DJ Quik

West 108th Street & Crenshaw Boulevard, Inglewood

Photo: Rob La

"WHY DON'T YOU BRING YOUR ASS ON OVER TO CRENSHAW & SLAUSON, TAKE A WALK THROUGH THE HOOD AND WE UP TO NO GOOD"

— Kurupt

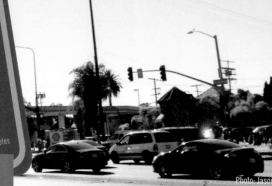

Crenshaw Boulevard & West Slauson Avenue, South Los Angeles

Photo: Jason S

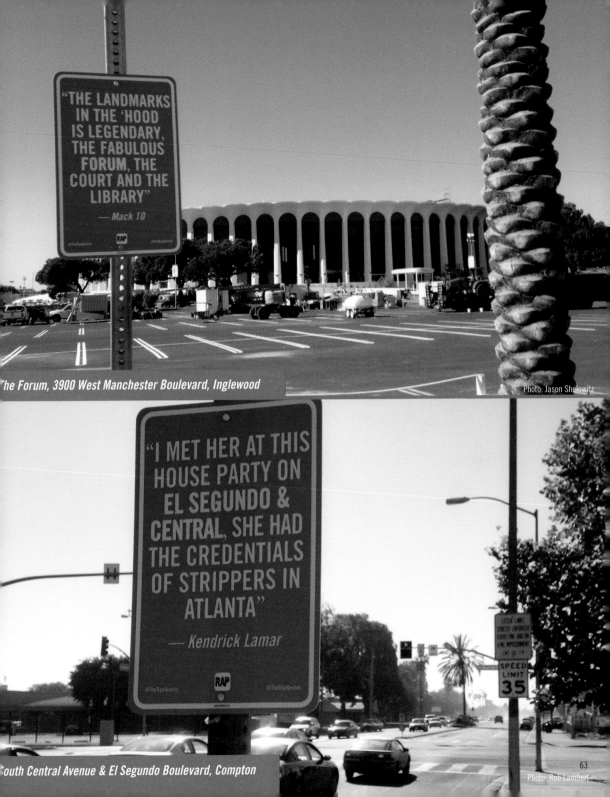

"THE LANDMARKS IN THE 'HOOD IS LEGENDARY, THE FABULOUS FORUM, THE COURT AND THE LIBRARY"

— Mack 10

The Forum, 3900 West Manchester Boulevard, Inglewood

"I MET HER AT THIS HOUSE PARTY ON EL SEGUNDO & CENTRAL, SHE HAD THE CREDENTIALS OF STRIPPERS IN ATLANTA"

— Kendrick Lamar

South Central Avenue & El Segundo Boulevard, Compton

21st ST 1000 b

Lewis AVE 2000

NO PARKING 12 NOON TO 4 PM WEDNESDAY STREET SWEEPING
L.B.M.C. 10.22.140

"SO I HOOKS A
LEFT ON 2-1 &
LEWIS, SOME
BROTHERS
SHOOTING DICE
SO I SAID LET'S
DO THIS"

— Warren G

21st Street & Lewis Avenue, Long Beach

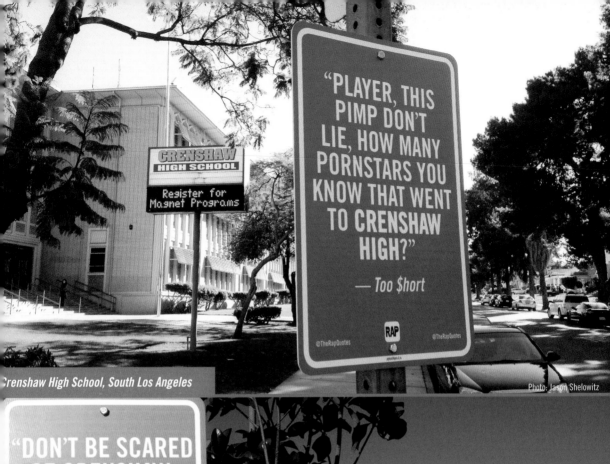

"PLAYER, THIS PIMP DON'T LIE, HOW MANY PORNSTARS YOU KNOW THAT WENT TO CRENSHAW HIGH?"

— Too $hort

@TheRapQuotes RAP @TheRapQuotes

Crenshaw High School, South Los Angeles

Photo: Jason Shelowitz

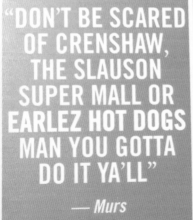

"DON'T BE SCARED OF CRENSHAW, THE SLAUSON SUPER MALL OR EARLEZ HOT DOGS MAN YOU GOTTA DO IT YA'LL"

— Murs

@TheRapQuotes RAP @TheRapQuotes

Earle'z Grille, 3864 Crenshaw Boulevard, Leimert Park

Photo: Jason Shelowitz

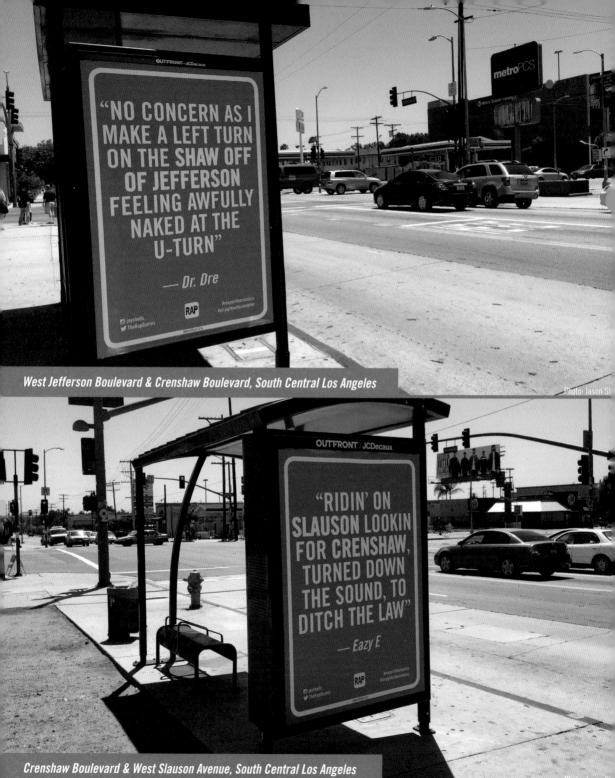

"NO CONCERN AS I MAKE A LEFT TURN ON THE SHAW OFF OF JEFFERSON FEELING AWFULLY NAKED AT THE U-TURN"

— Dr. Dre

West Jefferson Boulevard & Crenshaw Boulevard, South Central Los Angeles

Photo: Jason Si

"RIDIN' ON SLAUSON LOOKIN FOR CRENSHAW, TURNED DOWN THE SOUND, TO DITCH THE LAW"

— Eazy E

Crenshaw Boulevard & West Slauson Avenue, South Central Los Angeles

Photo: Jason Si

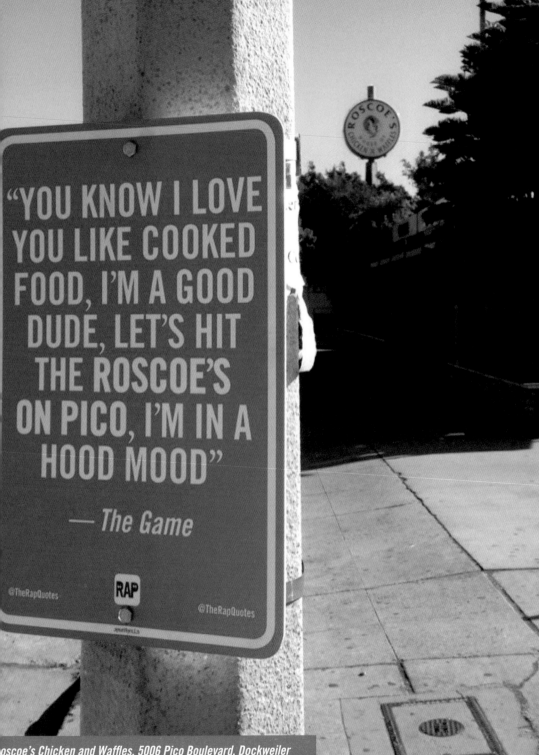

"YOU KNOW I LOVE YOU LIKE COOKED FOOD, I'M A GOOD DUDE, LET'S HIT THE ROSCOE'S ON PICO, I'M IN A HOOD MOOD"

— *The Game*

@TheRapQuotes

RAP

@TheRapQuotes

oscoe's Chicken and Waffles, 5006 Pico Boulevard, Dockweiler

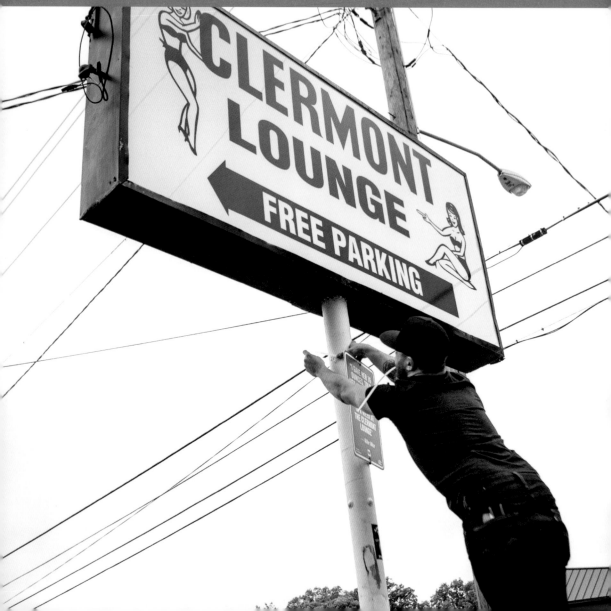

" Often-repeated and rarely researched fact: Atlanta, Georgia runs the rap game. Since when? Well, that depends on who, when and where you ask. Ask a Midwesterner who moved there in the '80s for school or work, and they'll tell you since Arrested Development won two Grammys for their debut album in 1993. Ask a spades table full of late-30 somethings at a cookout in Decatur and they'll name anytime between Outkast's first and third classic albums. Ask a budding nightclub DJ on the Southside in the middle of his "new Atlanta" set and they'll tell you since Lil Jon crunked the world. So yeah, when you ask "since when" you will get a lot of different answers, but at least you will get one.

But, when you bother looking into why Atlanta runs the rap game, you find yourself traveling down a lot of renamed streets leading to renovated buildings with no concrete answer in sight. The sign to the left will tell you it's because Atlanta artists stick together while the one to the right will tell you because rappers from everywhere else move there to work. The sign across the street will say it's because the radio stations (where pay-for-play is supposed to be illegal) play local artists while the one in the rearview says it's because the strip clubs (where pay-for-play is the rule) will play anything off the street as long as asses keep shaking. But the sign that's been standing the longest will tell you it's because the city and its rap artists are constantly reinventing themselves. Just like how the city rebranded itself as "too busy to hate" post-Jim Crow, Atlanta's rap music rebrands itself every time the rest of the world catches up.

In the last three decades Atlanta's sound and style has morphed from bootyshake to playalistic to conscious to crunk to snap to trap to pop. Both CeeLo Green and Young Thug have rocked everything from Braves jerseys and Jordans to women's dresses and fingernail polish. 38-year old Gucci Mane is a grandfather of at least two generations of Atlanta rap and grew from a drug addict to a gym rat in the process.

Simultaneously, Atlanta itself has also become known for paving over its own history in the process. Streets get renamed when new money comes around. Neighborhoods get demolished when new leadership gets voted in. Cultural institutions crumble when the kids who grew up in them get old and rich enough to move out. These sometimes gradual, most times rapid, changes are well documented in the music that comes out of the city.

The Bankhead Highway T.I. made famous now pops up as Donald Lee Hollowell in Google Maps. The Bowen Homes projects Andre 3000 and a swarm of kids ran through in the technicolored "Bombs Over Baghdad" video is now a gray and tan void. In '95 T-Mo Goodie rapped about not having enough money to go inside Lenox Mall while his Dungeon Family sibling Future raps about blowing racks there 20 years later.

When you read Atlanta's contributions to The Rap Quotes, locations aren't the only things to be cherished. Differences in lifestyle and mentality are also captured. Memories are cemented, even if the people who created them may have forgotten about them. "

MAURICE GARLAND

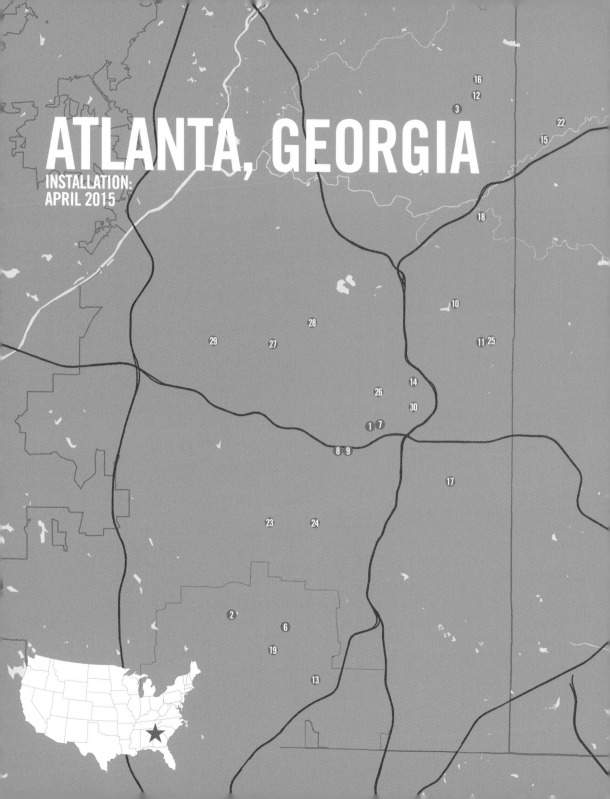

ATLANTA, GEORGIA

INSTALLATION:
APRIL 2015

1 **Andre 3000:**
"At **Magic City** shakin' titties just to pay the rent, Lord trying to hustle must be something that was heaven sent"

2 **Andre 3000:**
"One for the money yessir, two for the show, a couple of years ago on **Headland & Delowe**, was the start of something good"

3 **B.o.B.:**
"But when I'm on the grind I'm headed down to Frequency, or downtown in Atlanta at **Havana's** yes indeed"

4 **B.o.B.:**
"So in my senior year at **Columbia High**, I dropped out of high school and I got signed"

5 **B.o.B.:**
"Well, you already know where I be, I'll be off of **Candler Road right off of 20 East**"

6 **Big Boi:**
"I got an ounce of dank and a couple of drinks, so let's crank up a session like **Tri-Cities High School** was pulling 'em in a broke down Rabbit"

7 **Big Boi:**
"Monday night, Atlanta, Georgia, they say all the hoes at **Magic** see no I'm no David Copperfield but I'm sure I can pull a rabbit"

8 **Big Boi:**
"Never eating chicken thighs only the twenty piece **Mojo**, flow zone like Flojoe"

9 **Big Gipp:**
"Hot wings from **Mojo's** got my forehead sweating, celery and blue cheese on my menu next"

10 **Big Gipp:**
"Mack town keeps growing old school like Charles, stankin' like dem Lincolns in **Piedmont Park**"

11 **Bubba Sparxxx:**
"I'm finna meet this bitch up at the **Clermont Lounge**, the money's low but I dare not scrounge"

12 **Canibus:**
"Whenever I get bored, I just jump in my car, I go to **Lenox Mall**, and look for independent broads"

13 **Cool Breeze:**
"See **Martel Homes** that's my claim to fame, that's where I learned my slickest tricks in the dope-d-game"

14 **Drake:**
"The one that I needed was Courtney from **Hooters on Peachtree**, I've always been feeling like she was the piece to complete me"

15 **Future:**
"Ballin' with no budget, get a rental car from Budget, got the waitress at the **Pink Pony** ridin' with the luggage"

16 **Future:**
"On my way to **Phipps Plaza**, hit Gucci in a rush"

17 **Gucci Mane:**
"Birds everywhere lookin' like **Atlanta Zoo**, pounds in a stash bag chickens in da coop"

18 **Gucci Mane:**
"I'm at **Club Onyx** fuckin' with the strippers, I tip 'em, squeeze your nipples, squeeze your nipples"

19 **Jermaine Dupri:**
"Friday: **Shark Bar**, Kaya with Frank Ski, right on the flo is where you can find me"

20 **Jermaine Dupri:**
"Tuesday night: I'm up in the **Velvet Room** gettin fucked up; Wednesday: I'm at Strokers on lean; Thursday: Jump clean then I fall up in Cream"

21 **Jermaine Dupri:**
"Tuesday night: I'm up in the Velvet Room gettin fucked up; Wednesday: I'm at **Strokers** on lean; Thursday: Jump clean then I fall up in Cream"

22 **Jermaine Dupri:**
"Tuesday night: I'm up in the Velvet Room gettin fucked up; Wednesday: I'm at Strokers on lean; Thursday: Jump Clean then I fall up in **Cream**"

23 **Khujo Goodie:**
"I'm on **1365 Wichita Drive**, ole' burd working the stove ride"

24 **Khujo Goodie:**
"Rollin' down **Main Street East Point**, I swerve, **Campbellton Road**, Southside, 8:55"

25 **Killer Mike:**
"I gave her 16 ounces, told her: 'hold daddy down and I'll meet you in a week at the **Clermont Lounge**'"

26 **Ludacris:**
"I wanna get you in the **Georgia Dome** on the 50 yard line, while the Dirty Birds kick for three"

27 **T-Mo:**
"**Bankhead Seafood** making me hit that door with a mind full of attitude"

28 **TI:**
"How many rappers you know that could hold they own on **Rice Street**? East steady talkin' on the cell phone nightly"

29 **TI:**
"I got a front street swag and a side street hustle, **Center Hill, Cedar Ave.** that's where I be sucka"

30 **Young Jeezy:**
"Bad habits, I'm at **Walter's** every week, 50 pair of new Nike Airs ain't cheap"

Special thanks to Mike Walbert and the A3C team for sponsoring the Atlanta installation.

71

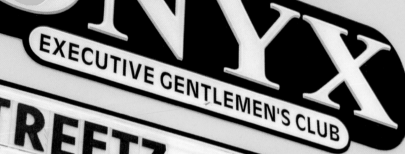

ONYX
EXECUTIVE GENTLEMEN'S CLUB

STREETZ FEST
KICK OFF
FRIDAY 17TH

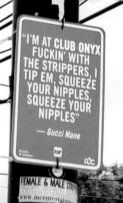

"I'M AT CLUB ONYX FUCKIN' WITH THE STRIPPERS, I TIP EM, SQUEEZE YOUR NIPPLES, SQUEEZE YOUR NIPPLES"

— Gucci Mane

FEMALE & MALE STR
678-7
www.nicentertainment

Liddell Dr

Cheshire Br R

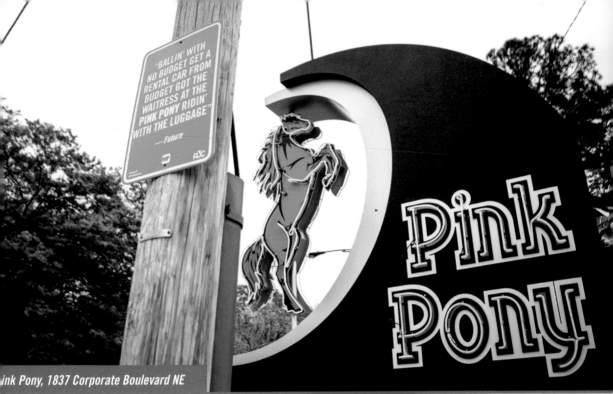

"BALLIN' WITH NO BUDGET GET A RENTAL CAR FROM BUDGET GOT THE WAITRESS AT THE **PINK PONY** RIDIN' WITH THE LUGGAGE"

— Future

Pink Pony, 1837 Corporate Boulevard NE

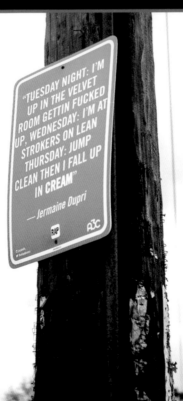

"TUESDAY NIGHT: I'M UP IN THE VELVET ROOM GETTIN FUCKED UP, WEDNESDAY: I'M AT STROKERS ON LEAN THURSDAY: JUMP CLEAN THEN I FALL UP IN **CREAM**"

— Jermaine Dupri

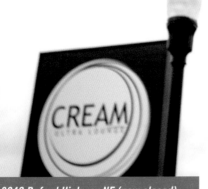

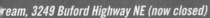
Cream, 3249 Buford Highway NE (now closed)

73

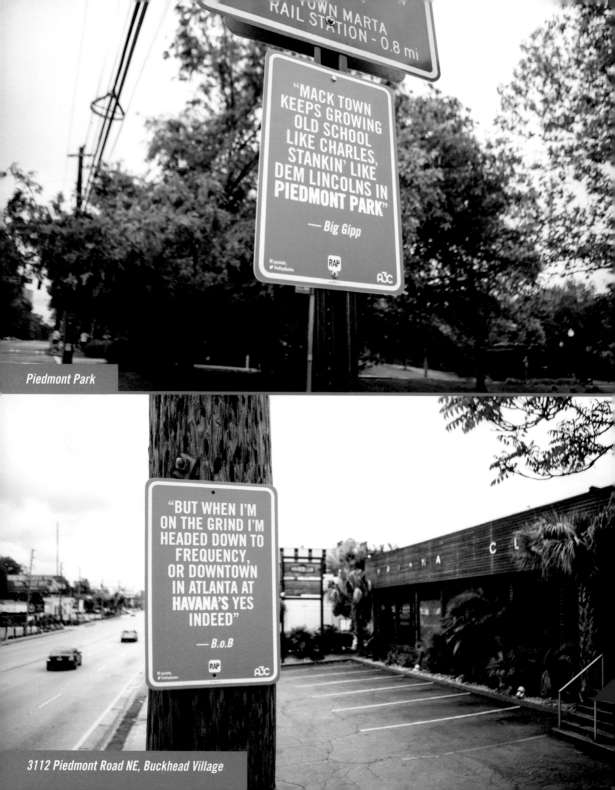

TOWN MARTA
RAIL STATION - 0.8 mi

"MACK TOWN
KEEPS GROWING
OLD SCHOOL
LIKE CHARLES,
STANKIN' LIKE
DEM LINCOLNS IN
PIEDMONT PARK"

— *Big Gipp*

RAP
A3C

Piedmont Park

"BUT WHEN I'M
ON THE GRIND I'M
HEADED DOWN TO
FREQUENCY,
OR DOWNTOWN
IN ATLANTA AT
HAVANA'S YES
INDEED"

— *B.o.B*

RAP
A3C

3112 Piedmont Road NE, Buckhead Village

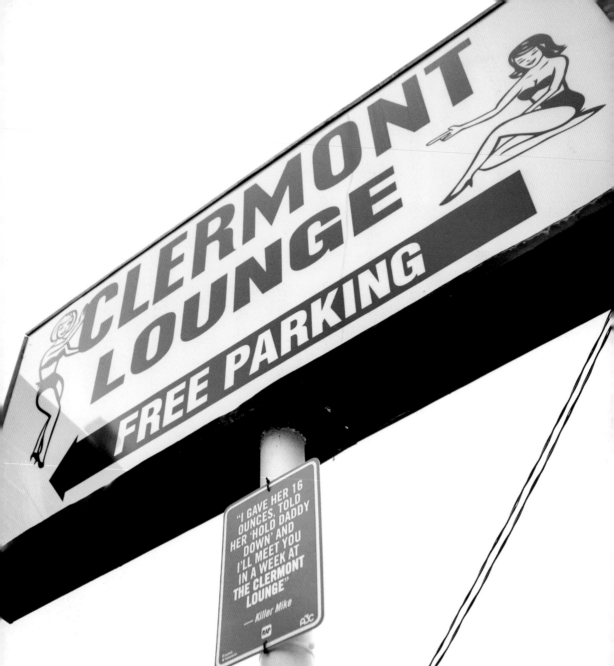

CLERMONT LOUNGE

FREE PARKING

"I GAVE HER 16 OUNCES, TOLD HER 'HOLD DADDY DOWN' AND I'LL MEET YOU IN A WEEK AT THE CLERMONT LOUNGE"

— *Killer Mike*

lermont Lounge, 789 Ponce De Leon Avenue NE

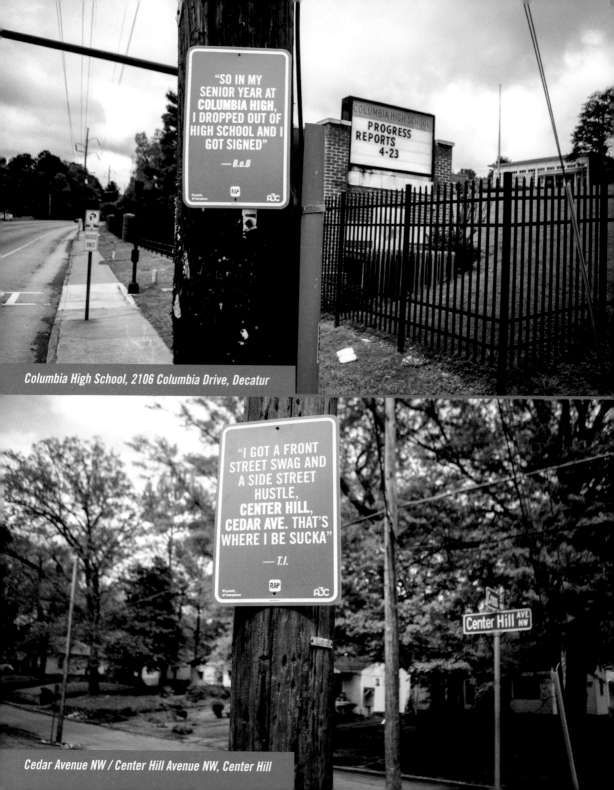

"SO IN MY
SENIOR YEAR AT
COLUMBIA HIGH,
I DROPPED OUT OF
HIGH SCHOOL AND I
GOT SIGNED"

— B.o.B

Columbia High School, 2106 Columbia Drive, Decatur

"I GOT A FRONT
STREET SWAG AND
A SIDE STREET
HUSTLE,
CENTER HILL,
CEDAR AVE. THAT'S
WHERE I BE SUCKA"

— T.I.

Cedar Avenue NW / Center Hill Avenue NW, Center Hill

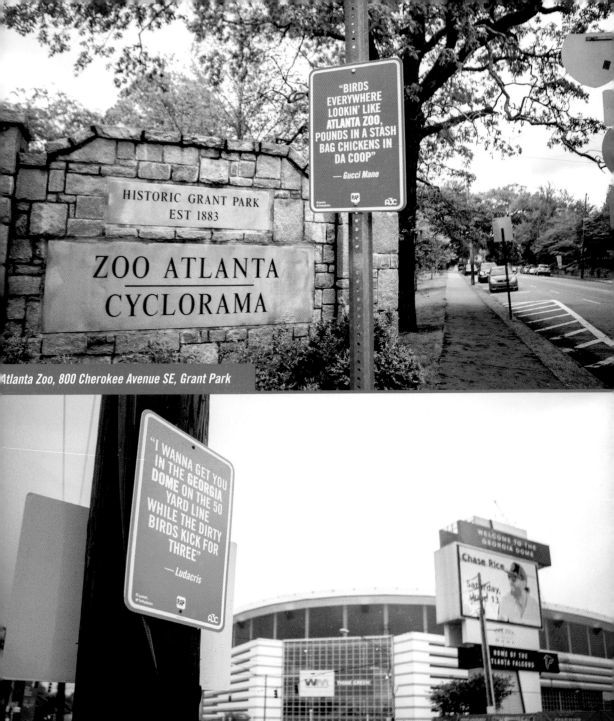

HISTORIC GRANT PARK
EST 1883

ZOO ATLANTA
CYCLORAMA

"BIRDS EVERYWHERE LOOKIN' LIKE ATLANTA ZOO, POUNDS IN A STASH BAG CHICKENS IN DA COOP"
— Gucci Mane

Atlanta Zoo, 800 Cherokee Avenue SE, Grant Park

"I WANNA GET YOU IN THE GEORGIA DOME ON THE 50 YARD LINE WHILE THE DIRTY BIRDS KICK FOR THREE"
— Ludacris

Georgia Dome, 1 Georgia Dome Drive, Downtown (now demolished)

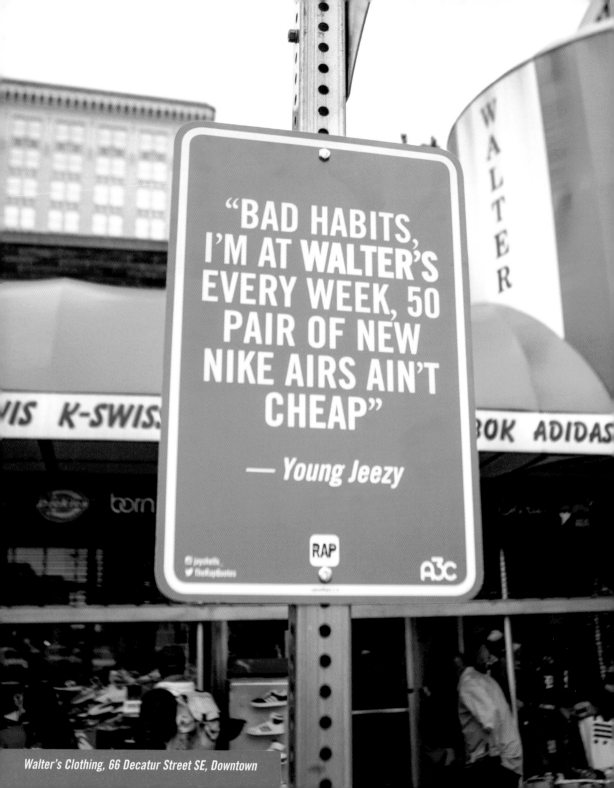

"BAD HABITS, I'M AT **WALTER'S** EVERY WEEK, 50 PAIR OF NEW NIKE AIRS AIN'T CHEAP"

— *Young Jeezy*

RAP

A3C

Walter's Clothing, 66 Decatur Street SE, Downtown

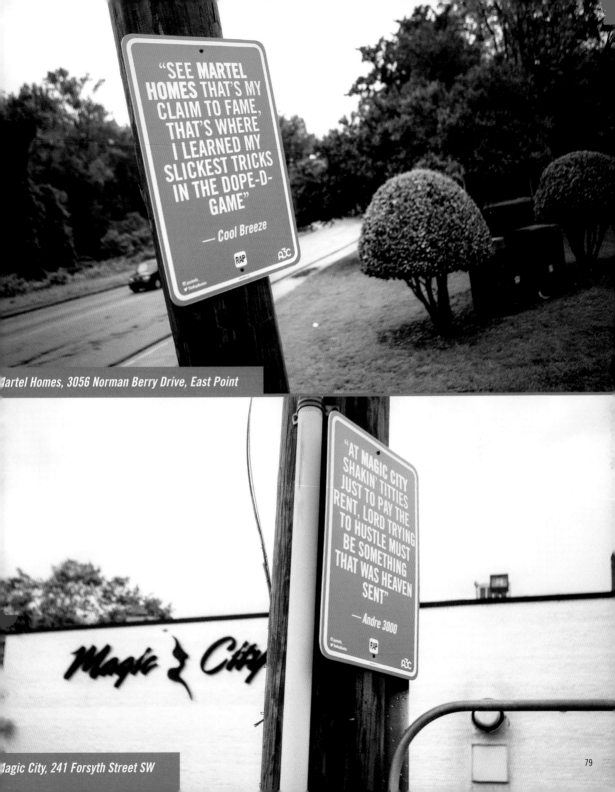

"SEE MARTEL HOMES THAT'S MY CLAIM TO FAME, THAT'S WHERE I LEARNED MY SLICKEST TRICKS IN THE DOPE-D-GAME"

— Cool Breeze

Martel Homes, 3056 Norman Berry Drive, East Point

"AT MAGIC CITY SHAKIN' TITTIES JUST TO PAY THE RENT, LORD TRYING TO HUSTLE MUST BE SOMETHING THAT WAS HEAVEN SENT"

— Andre 3000

Magic City, 241 Forsyth Street SW

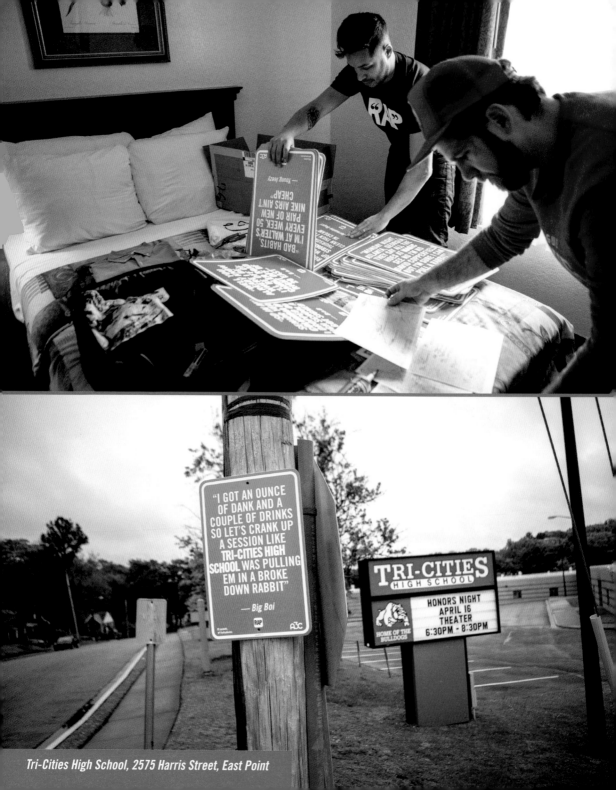

Tri-Cities High School, 2575 Harris Street, East Point

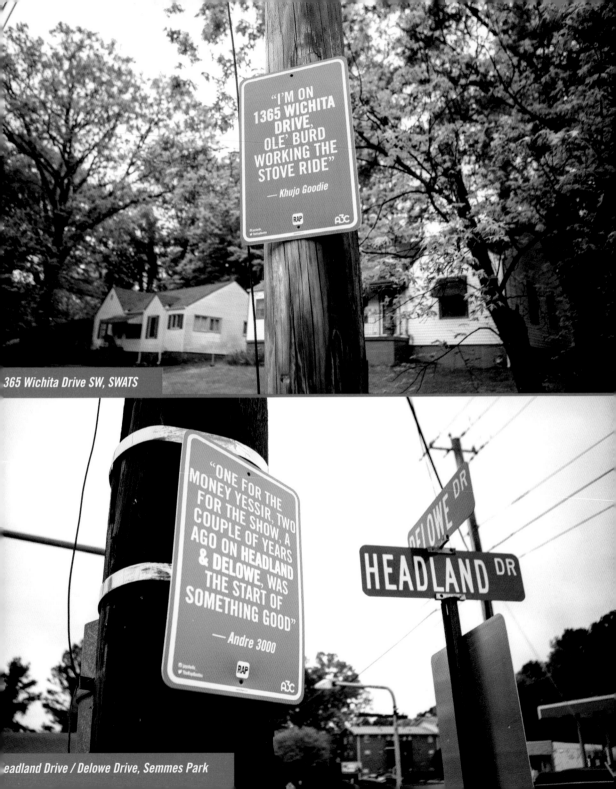

"I'M ON 1365 WICHITA DRIVE, OLE' BURD WORKING THE STOVE RIDE"

— *Khujo Goodie*

RAP A3C

365 Wichita Drive SW, SWATS

"ONE FOR THE MONEY YESSIR, TWO FOR THE SHOW, A COUPLE OF YEARS AGO ON HEADLAND & DELOWE, WAS THE START OF SOMETHING GOOD"

— Andre 3000

RAP A3C

DELOWE DR

HEADLAND DR

eadland Drive / Delowe Drive, Semmes Park

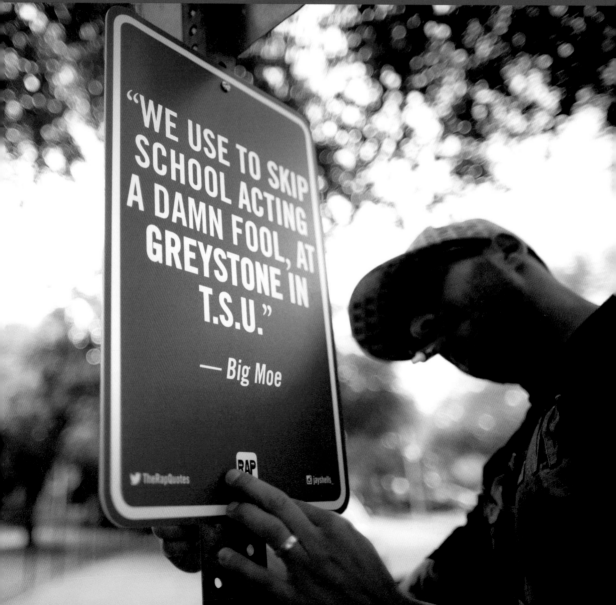

"WE USE TO SKIP SCHOOL ACTING A DAMN FOOL, AT GREYSTONE IN T.S.U."

— Big Moe

It has always been an outpost, Houston, Texas. Too far away from "either" coast (though it *does* have one of its own), with no centralized music industry of which to speak and a remarkable inability to attract media attention to its talent the way an artist from a sexier market might. But Houston music has weathered those omissions, especially in its hip hop community, which itself is a reflection of the city: dozens of microcommunities, seemingly disassociated, often deeply connected. Houston is a small town metropolis, and you can tell when you drive through the neighborhoods. When hip hop began to bloom in the Bayou City, it was apparent that it was never going to be another New York or Los Angeles, especially when the music got slower. It was just too spread out. Things in Houston move at the speed of Texas.

So I was happy to see the biggest city in the South woven into Jason Shelowitz's Rap Quotes project, because I have documented Houston hip hop music since 2005 and I know how important a sense of place is in the music. In the lyrics that appear on Jason's signs—with K-Rino rapping about MacGregor Park, Z-Ro passing through Fondren and Main in Mo City, Devin the Dude talking about a trip to King's Flea Market in South Park, Scarface talking about his block in South Acres, Lil' Keke on Herschelwood, or the late Mr. 3-2 talking about his own forthcoming death (and how he wanted to be buried next to the Come N Go in his neighborhood of Hiram Clarke)—the art is what is being shared. But sharing the art is also sharing the truth, and when the late Big H.A.W.K. wrote about driving around the Astrodome—which almost anyone who visits

Houston does—he illustrated something universal in that we might take the same streets, but we're all coming from somewhere else, and we're all going somewhere else.

These artists chose to shine a spotlight on their part of the map, and they all had different reasons. Big Moe, Bushwick Bill, Travis Scott, and even Drake—whose love for the city he has made abundantly clear over the years—all of them permanently, in verse, talking about the geography of Houston. It's endless. That's not why they call it Space City, but there sure is a lot of space. These are star maps for a different kind of star. The constellations are the connections between artists. A deeper understanding of Houston results.

The Rap Quotes is a microscope into the music. The lyricism highlighted is just one element. The other is the sense of ownership Houstonians feel over the music their city produces, and the places that turn up in the songs. The music is invested in the people because the music is invested in the city. Houston owns it, and that is being shown anew. Jay Shells has taken the familiar and turned it royal, bringing all of these different artists into a new map, a new layer over the culture that crystallizes the talents of its citizens, elevating the artistry through tributes that become living monuments amongst the people, bringing all of these Houston artists together in a love letter to a city and its people written in a unique and generous new form.

LANCE SCOTT WALKER

HOUSTON, TEXAS

INSTALLATION:
SEPTEMBER 2018

off the

1 Big H.A.W.K.:
"Riding on chrome banging with my bub lights on, riding home I reach southeast of the **Astrodome**"

2 Big Moe:
"She said Moe-yo, I didn't know that you rap, I remember you singing, way back at the **Jack Yates** in a Delta 88, scraping plates."

3 Big Moe:
"We used to skip school acting a damn fool, at **Greystone in T.S.U.**"

4 Big Pokey:
"Heads up when you see us, we gon' put it in ya face, raised on **Scott & Yellow**, when I blaze"

5 Bun B:
"Chrome, looking more glassy than the **Transco Tower**, car drippin' candy pain't like it just came out the shower"

6 Bushwick Bill:
"A school ho she attended **U of H**, a law student who was looking for a fuckin' case"

7 Devin the Dude:
"I'll get some booze and a sack and we can hit the **King's Flea Market** shop 'till we drop, I'll probably get you a ring"

8 Drake:
"I got some shit for you to come and get, I'm at the **St. Regis up on Briar Oaks**, hit me when you done your shift"

9 Drake:
"Man I know that place like I come from it, backstage at **Warehouse** in '09 like is Bun coming?"

10 Drake:
"That's why you gotta come through quick, quick, I'm posted at **The Derek up on Westheimer**, hit me when you're done your shift"

11 Drake:
"Thinking 'bout Texas, back when Porsche used to work at **Treasures** or further back than that, before I had the Houston leverage"

12 Fat Pat:
"I'm starched down, piece on my neck I don't play, **Ike** will spray, leave candy red came up out the shop, and I turned a lot of heads"

13 Fat Tony:
"Coming straight up out the Tre, that's **MacGregor Park**, straight out Third Ward"

14 Fat Tony:
"**MacGregor Park**, grooving on a sunday, the sweetest park, n---a, let's have a fun day"

15 Ganksta N-I-P:
"A weed-smoking motherfucker, plus I kick doobies, I'm the one that told that n---a to go insane in that **Luby's**"

16 K-Rino:
"I was chilling at **MacGregor Park** minding my own, my boy bomber kicking back on the cellular phone"

17 K-Rino:
"My wardrobe is simple, no one cares how much it costed, this shirt was $9.99 at **King's Flea Market**"

18 K-Rino:
"I was raised in the Dead End, the park is my hood Esperanza, **King's Gate**, Orleans, Summer Wood"

19 Lil Flip:
"I wreck **I-45**, I wreck 2 screw tapes, I'm 3 wheelin' poppin' trunk goin' down **Fuqua**"

20 Lil Keke:
"Born and raised on the **8100 block of Herschelwood** and the point is understood"

21 Lil Keke:
"I swung and I swang, you know that n---a clean hit the **Bellfort and the King**, Europeans with the screens"

22 Lil O:
"For my hustlers in southwest, Wood Fair & Club Creek to all my **8900 Braeswood** block G's"

23 Lil O:
"For my hustlers in southwest, **Wood Fair & Club Creek** to all my 8900 Braeswood block G's"

24 Mr. 3-2:
"And if I die or should I say if I go, bury me in **Hiram Clarke** next to the **Come n Go**"

25 Paul Wall:
"I'm on Scott, in the turning lane, I'm headed straight to that **Timmy Chan's**, order up and let's get some wangs"

26 Paul Wall:
"Paul Wall baby what you know bout me, I'm on that **59 Southlea** baby holler at me"

27 Raheem:
"Never trust a bitch and learned to juggle cocaine, keep a n---a's ass off of **Liberty & Waco** cause that right there's a corner that the hardrock claim"

28 Scarface:
"Full speed down **Reed**, shot his mom on the porch on his way down **Cullen**, his brother was just dazed in a shock, 'why you do it?'"

29 Scarface:
"That's me dog, on my block, I ain't have to play the big shot n----s knew me back when I was stealing beer from **Shamrock**"

30 Scarface:
"To my block, from Holloway, **Bellfort to Scott**, Reed Road to Phlox, we know the spots"

31 Scarface:
"To my block, from Holloway, Bellfort to Scott, **Reed Road to Phlox**, we know the spots"

32 Scarface:
"I met her in the **Galleria** shopping, buying gifts for some guy that she dating"

33 Scarface:
"Went and seen my homie short dog that slided me a track, went to **Mason's Pawn Shop** and got me a gat"

34 Slim Thug:
"These n----s don't understand me, cuz I'm boss hogg on candy, top down at **Max's** wit a big glock nine handy"

35 Travis Scott:
"Don't bring that to the crib, keep that in the lobby, you never seen the city unless you land at **Hobby**"

36 Travis Scott:
"Packin' out **Toyota** like I'm in the league, and it ain't a mosh pit if ain't no injuries"

37 Wale:
"My favorite bitch at **Dream** be stripping around 2, she love to say 'I fuck with you, thank you for coming through'"

38 Z-Ro:
"Ain't no thing, like a chicken wing, coming down **Fondren**, right on **Main**"

39 Z-Ro:
"Ya'll already know Z -Ro be runnin' the streets all day, back in **Willowridge** I wasn't in the classroom 'Ro was in the hallway"

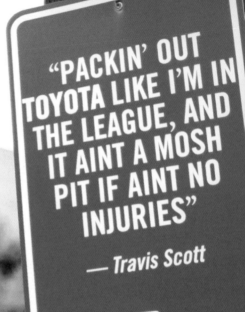

"PACKIN' OUT TOYOTA LIKE I'M IN THE LEAGUE, AND IT AINT A MOSH PIT IF AINT NO INJURIES"

—— Travis Scott

RAP

TheRapQuotes

jayshe

Toyota Center, 1510 Polk Street, Central Business District

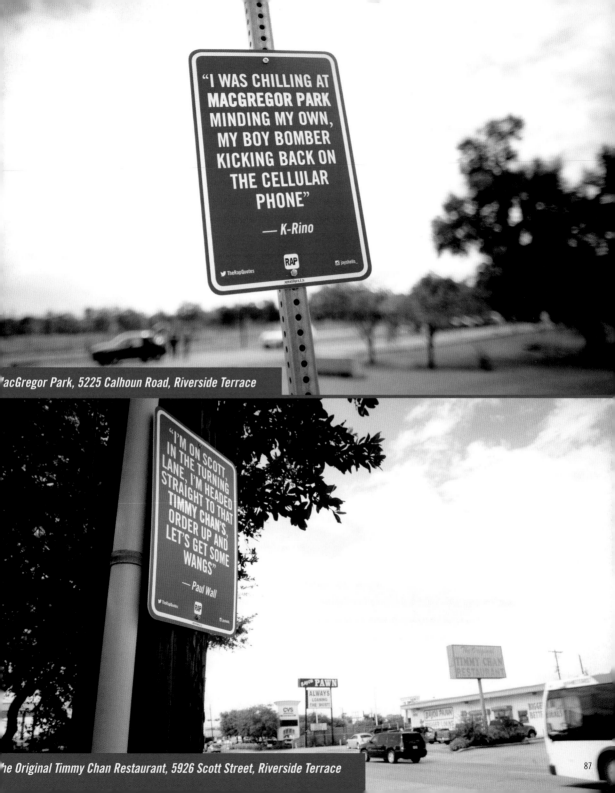

"I WAS CHILLING AT MACGREGOR PARK MINDING MY OWN, MY BOY BOMBER KICKING BACK ON THE CELLULAR PHONE"

— K-Rino

MacGregor Park, 5225 Calhoun Road, Riverside Terrace

"I'M ON SCOTT, IN THE TURNING LANE, I'M HEADED STRAIGHT TO THAT TIMMY CHAN'S, ORDER UP AND LET'S GET SOME WANGS"

— Paul Wall

The Original Timmy Chan Restaurant, 5926 Scott Street, Riverside Terrace

87

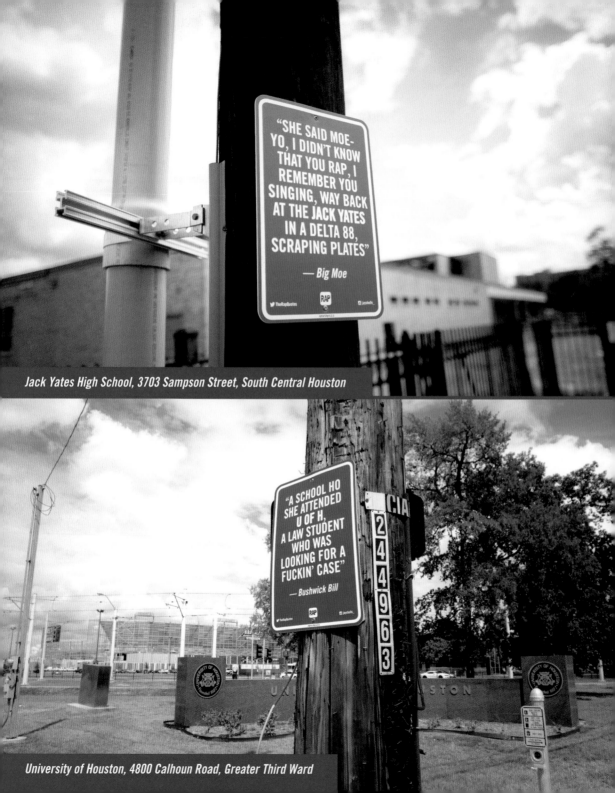

"SHE SAID MOE-YO, I DIDN'T KNOW THAT YOU RAP, I REMEMBER YOU SINGING, WAY BACK AT THE JACK YATES IN A DELTA 88, SCRAPING PLATES"

— Big Moe

Jack Yates High School, 3703 Sampson Street, South Central Houston

"A SCHOOL HO SHE ATTENDED U OF H, A LAW STUDENT WHO WAS LOOKING FOR A FUCKIN' CASE"

— Bushwick Bill

University of Houston, 4800 Calhoun Road, Greater Third Ward

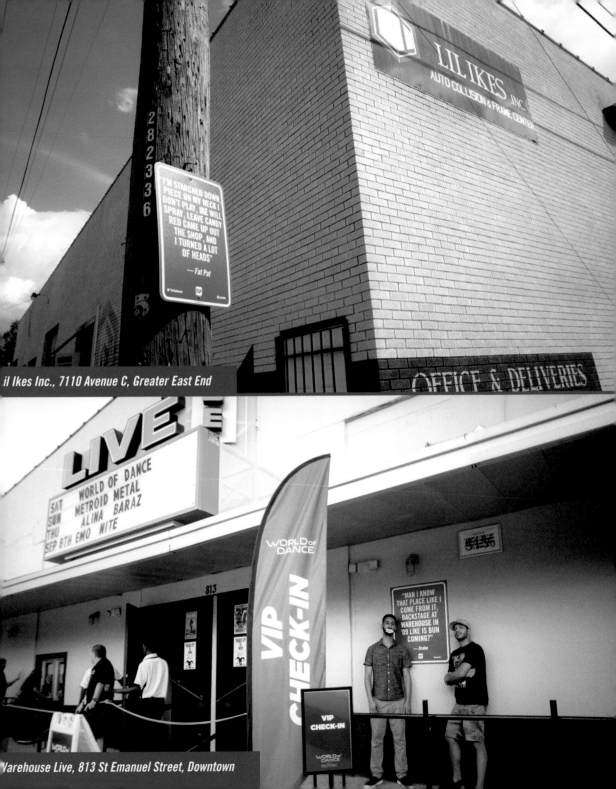

LIL IKES INC.
AUTO COLLISION & FRAME CENTER

2 8 2 3 3 6

"I'M STARCHED DOWN
PIECE ON MY NECK I
DON'T PLAY, WE WILL
SPRAY, LEAVE CANDY
RED CAME UP OUT
THE SHOP, AND
I TURNED A LOT
OF HEADS"

—Fat Pat

OFFICE & DELIVERIES

Lil Ikes Inc., 7110 Avenue C, Greater East End

LIVE

WORLD OF DANCE

SAT WORLD OF DANCE
SUN METROID METAL
THU ALINA BARAZ
SEP 8TH EMO NITE

WORLD OF DANCE

VIP CHECK-IN

813

"MAN I KNOW
THAT PLACE LIKE I
COME FROM IT,
BACKSTAGE AT
WAREHOUSE IN
'09 LIKE IS BUN
COMING?"

—Drake

VIP
CHECK-IN

WORLD OF DANCE

Warehouse Live, 813 St Emanuel Street, Downtown

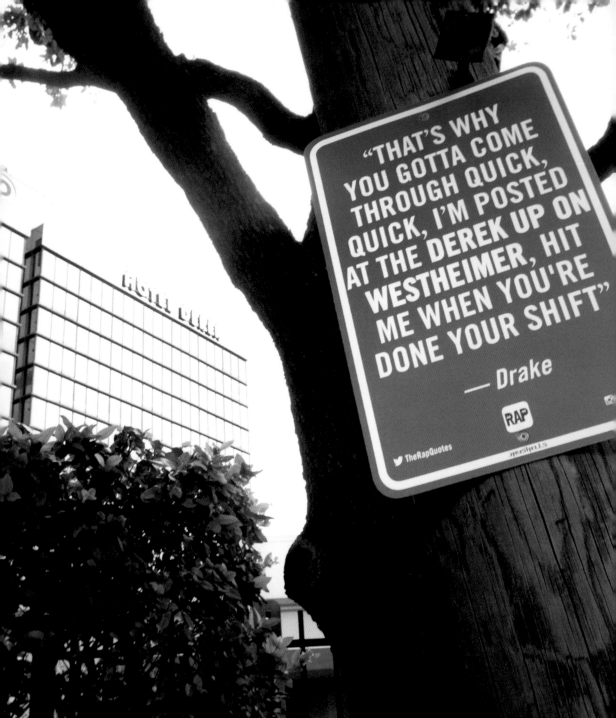

"THAT'S WHY YOU GOTTA COME THROUGH QUICK, I'M POSTED AT THE DEREK UP ON WESTHEIMER, HIT ME WHEN YOU'RE DONE YOUR SHIFT"

— Drake

RAP

TheRapQuotes

Hotel Derek, 2525 West Loop South, Afton Oaks

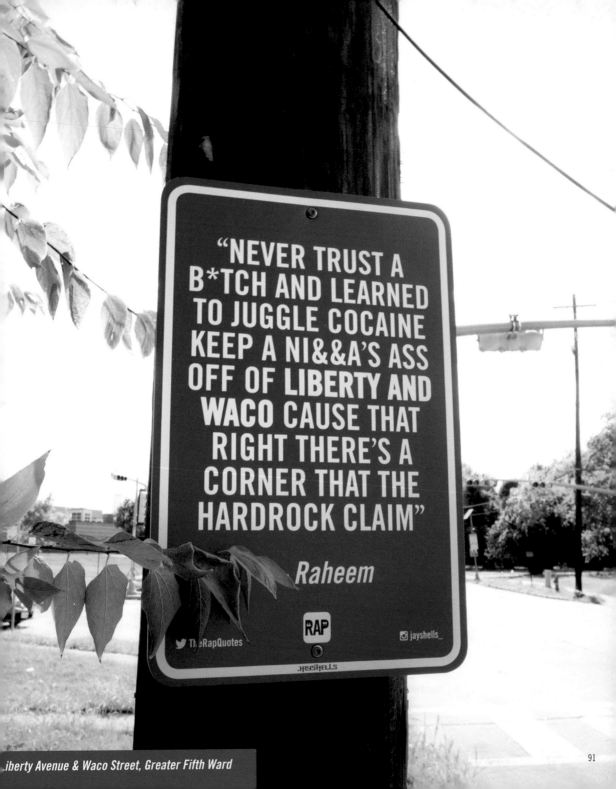

"NEVER TRUST A B*TCH AND LEARNED TO JUGGLE COCAINE KEEP A NI&&A'S ASS OFF OF **LIBERTY** AND **WACO** CAUSE THAT RIGHT THERE'S A CORNER THAT THE HARDROCK CLAIM"

Raheem

🐦 TheRapQuotes 📷 jayshells_

Liberty Avenue & Waco Street, Greater Fifth Ward

91

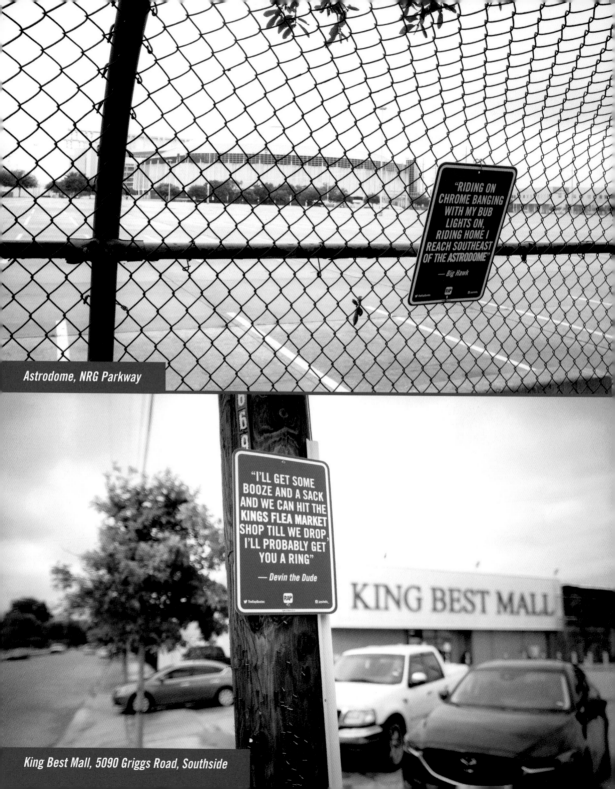

"RIDING ON CHROME BANGING WITH MY BUB LIGHTS ON, RIDING HOME I REACH SOUTHEAST OF THE ASTRODOME"

— *Big Hawk*

Astrodome, NRG Parkway

"I'LL GET SOME BOOZE AND A SACK AND WE CAN HIT THE KINGS FLEA MARKET SHOP TILL WE DROP, I'LL PROBABLY GET YOU A RING"

— *Devin the Dude*

King Best Mall, 5090 Griggs Road, Southside

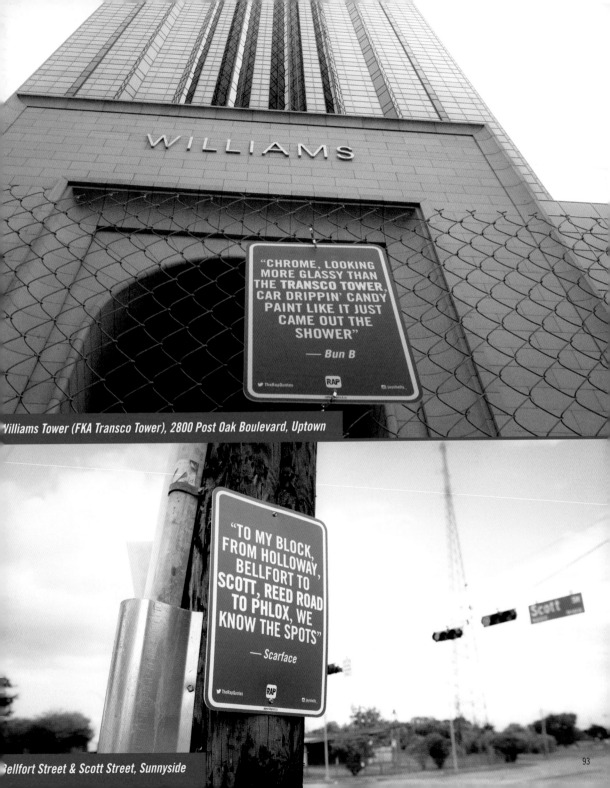

"CHROME, LOOKING MORE GLASSY THAN THE TRANSCO TOWER, CAR DRIPPIN' CANDY PAINT LIKE IT JUST CAME OUT THE SHOWER"

— Bun B

Williams Tower (FKA Transco Tower), 2800 Post Oak Boulevard, Uptown

"TO MY BLOCK, FROM HOLLOWAY, BELLFORT TO SCOTT, REED ROAD TO PHLOX, WE KNOW THE SPOTS"

— Scarface

Bellfort Street & Scott Street, Sunnyside

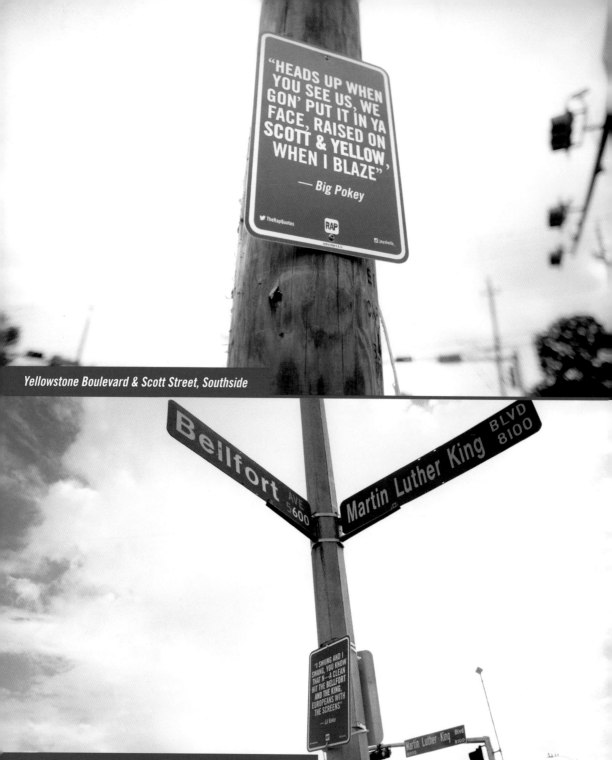

Yellowstone Boulevard & Scott Street, Southside

Bellfort Avenue & Martin Luther King Boulevard, Southpark

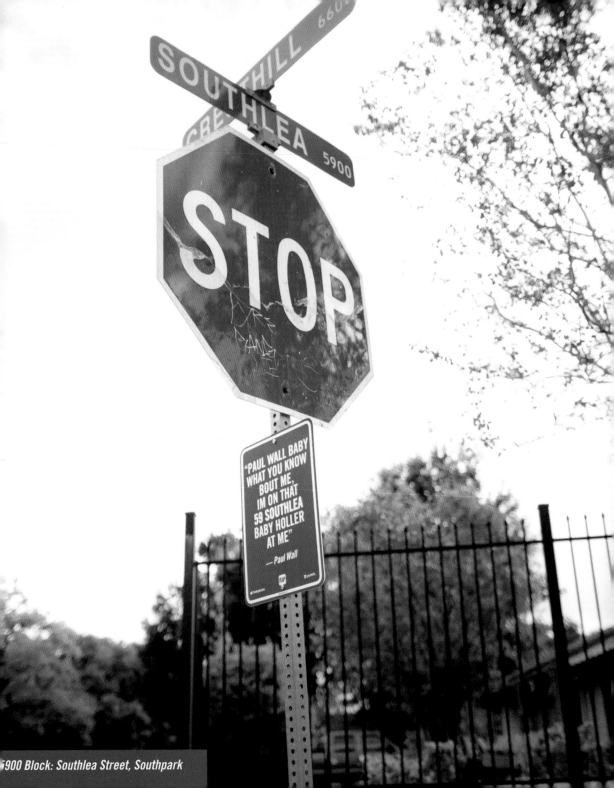

900 Block: Southlea Street, Southpark

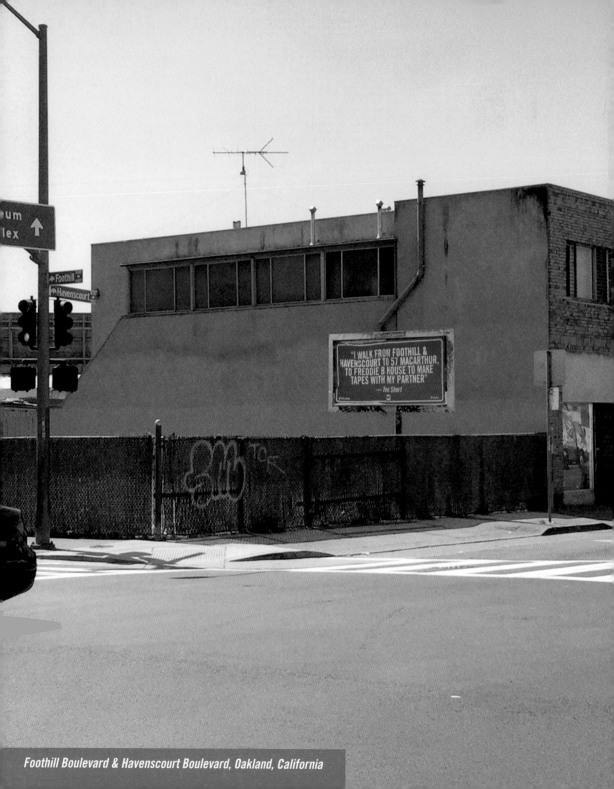

Foothill Boulevard & Havenscourt Boulevard, Oakland, California

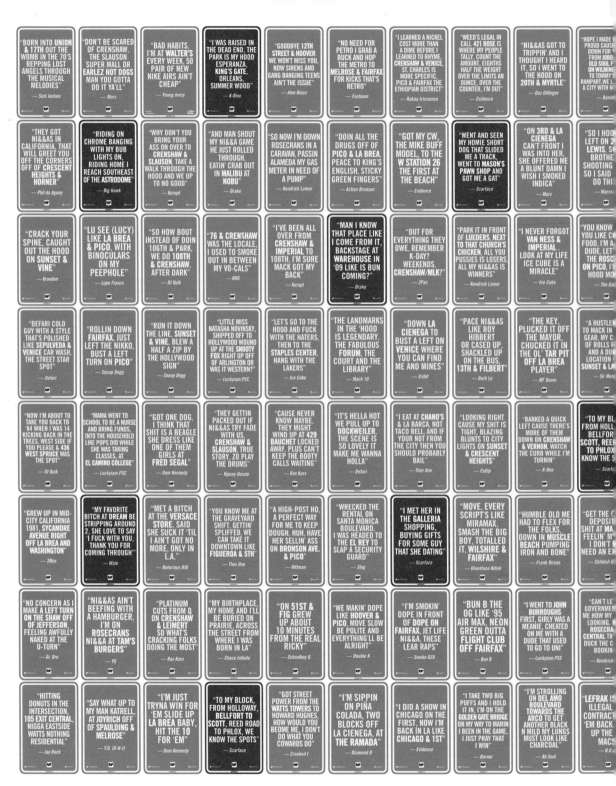

"BORN INTO UNION & 17TH OUT THE WOMB IN THE 70'S REPPING LOST ANGELS THROUGH THE MUSICAL MELODIES"
— Sick Jacken

"DON'T BE SCARED OF CRENSHAW, THE SLAUSON SUPER MALL OR EARLEZ HOT DOGS MAN YOU GOTTA DO IT YA'LL"
— Murs

"BAD HABITS, I'M AT WALTER'S EVERY WEEK, 50 PAIR OF NEW NIKE AIRS AIN'T CHEAP"
— Young Jeezy

"I WAS RAISED IN THE DEAD END, THE PARK IS MY HOOD ESPERANZA, KING'S GATE, ORLEANS, SUMMER WOOD"
— K-Rino

"GOODBYE 12TH STREET & HOOVER WE WON'T MISS YOU, NOW SIRENS AND GANG BANGING TEENS AIN'T THE ISSUE"
— Aloe Blacc

"NO NEED FOR PETRO I GRAB A BUCK AND HOP THE METRO TO MELROSE & FAIRFAX FOR KICKS THAT'S RETRO"
— Fashawn

"I LEARNED A NICKEL COST MORE THAN A DIME BEFORE I LEARNED TO RHYME, CRENSHAW & VENICE, ST. CHARLES IS MORE SPECIFIC, PICO & FAIRFAX THE ETHIOPIAN DISTRICT"
— Rakaa Iriscience

"WEED'S LEGAL IN CALI. 421 ROSE IS WHERE MY PEOPLE TALLY, COUNT THE AMOUNT, EIGHTHS HALF THE WEIGHT OVER THE LIMITS AN OUNCE, OVER THE COUNTER, I'M OUT"
— Evidence

"NI&&AS GOT TO TRIPPIN' AND I THOUGHT I HEARD IT, SO I WENT TO THE HOOD ON 20TH & MYRTLE"
— Daz Dillinger

"HOPE I MADE I PROUD CAUSE DOWN FOR FROM JORDA ON WILKING TO TOMMY'S RAMPART, WE L A CITY WITH A
— Bambi

"THEY GOT NI&&AS IN CALIFORNIA, THAT WILL GREET YOU OFF THE CORNERS OFF OF CRESCENT HEIGHTS & HORNER"
— Phil da Agony

"RIDING ON CHROME BANGING WITH MY BUB LIGHTS ON, RIDING HOME I REACH SOUTHEAST OF THE ASTRODOME"
— Big Hawk

"WHY DON'T YOU BRING YOUR ASS ON OVER TO CRENSHAW & SLAUSON, TAKE A WALK THROUGH THE HOOD AND WE UP TO NO GOOD"
— Kurupt

"AND MAN SHOUT MY NI&&A GAME HE JUST ROLLED THROUGH, EATIN' CRAB OUT IN MALIBU AT NOBU"
— Drake

"SO NOW I'M DOWN ROSECRANS IN A CARAVAN, PASSIN ALAMEDA MY GAS METER IN NEED OF A PUMP"
— Kendrick Lamar

"DOIN ALL THE DRUGS OFF OF PICO & LA BREA, PEACE TO KING'S ENGLISH, STICKY GREEN FINGERS"
— Action Bronson

"GOT MY CW, THE MIKE BUFF MODEL, TO THE W STATION 26 THE FIRST AT THE BEACH"
— Evidence

"WENT AND SEEN MY HOMIE SHORT DOG THAT SLIDED ME A TRACK, WENT TO MASON'S PAWN SHOP AND GOT ME A GAT"
— Scarface

"ON 3RD & LA CIENEGA CAN'T FRONT I WAS INTO HER, SHE OFFERED ME A BLUNT DAMN I WISH I SMOKED INDICA"
— Murs

"SO I HOO LEFT ON 2 LEWIS, S BROTHE SHOOTING SO I SAID DO THI
— Warre

"CRACK YOUR SPINE, CAUGHT OUT THE HOOD ON SUNSET & VINE"
— Krondon

"LU SEE (LUCY) LIKE LA BREA & PICO, WITH BINOCULARS ON MY PEEPHOLE"
— Lupe Fiasco

"SO HOW BOUT INSTEAD OF DOIN 106TH & PARK, WE DO 108TH & CRENSHAW, AFTER DARK"
— DJ Quik

"76 & CRENSHAW WAS THE LOCALE, I USED TO SMOKE OUT IN BETWEEN MY VO-CALS"
— AMG

"I'VE BEEN ALL OVER FROM CRENSHAW & IMPERIAL TO 108TH, I'M SURE MACK GOT MY BACK"
— Kurupt

"MAN I KNOW THAT PLACE LIKE I COME FROM IT, BACKSTAGE AT WAREHOUSE IN '09 LIKE IS BUN COMING?"
— Drake

"OUT FOR EVERYTHING THEY OWE, REMEMBER K-DAY? WEEKENDS, CRENSHAW/MLK?"
— 2Pac

"PARK IT IN FRONT OF LUEDERS, NEXT TO THAT CHURCH'S CHICKEN, ALL YOU PUSSIES IS LOSERS, ALL MY NI&&AS IS WINNERS"
— Kendrick Lamar

"I NEVER FORGOT VAN NESS & IMPERIAL , LOOK AT MY LIFE ICE CUBE IS A MIRACLE"
— Ice Cube

"YOU KNOW YOU LIKE C FOOD, I'M A DUDE, LET THE ROSC ON PICO, I'L HOOD MO
— The Ga

"DEFARI COLD GUY WITH A STYLE THAT'S POLISHED LIKE SEPULVEDA & VENICE CAR WASH, THE STREET STAR SPOT"
— Defari

"ROLLIN DOWN FAIRFAX, JUST LEFT THE NIKKO, BUST A LEFT TURN ON PICO"
— Snoop Dogg

"RUN IT DOWN THE LINE, SUNSET & VINE, BLEW A HALF A ZIP BY THE HOLLYWOOD SIGN"
— Snoop Dogg

"LITTLE MISS NATASHA NOVINSKY, SHIPPED OFF TO HOLLYWOOD WOUND UP AT THE SNOOTY FOX RIGHT UP OFF OF ARLINGTON OR WAS IT WESTERN?"
— Luckyiam.PSC

"LET'S GO TO THE HOOD AND FUCK WITH THE HATERS, THEN TO THE STAPLES CENTER, HANG WITH THE LAKERS"
— Ice Cube

"THE LANDMARKS IN THE 'HOOD IS LEGENDARY, THE FABULOUS FORUM, THE COURT AND THE LIBRARY"
— Mack 10

"DOWN LA CIENEGA TO BUST A LEFT ON VENICE WHERE YOU CAN FIND ME AND MINES"
— Xzibit

"PACE NI&&AS LIKE ROY HIBBERT OR CASED UP, SHACKLED UP ON THE BUS, 13TH & FILBERT"
— Dark Lo

"THE KEY, PLUCKED IT OFF THE MAYOR, CHUCKED IT IN THE OL' TAR PIT OFF LA BREA PLAYER"
— MF Doom

"A HUSTLE TO MACK IN GEAR, MY C OF ROLLS R AND A DUF LOCATION SUNSET & LA
— Sir Men

"NOW I'M ABOUT TO TAKE YOU BACK TO '84 WHEN I WAS 14 KICKING BACK IN THE TREES, WEST SIDE IF YOU PLEASE & 436 WEST SPRUCE WAS THE SPOT"
— DJ Quik

"MAMA WENT TO SCHOOL TO BE A NURSE AND BRING FUNDS, INTO THE HOUSEHOLD LIKE POPS DID WHILE SHE WAS TAKING CLASSES, AT EL CAMINO COLLEGE"
— Luckyiam.PSC

"GOT ONE DOG, I THINK THAT SHIT IS A BEAGLE SHE DRESS LIKE ONE OF THEM GIRLS AT FRED SEGAL"
— Dom Kennedy

"THEY GETTIN PACKED OUT IF NI&&AS TRY FADE WITH US, CRENSHAW & SLAUSON, TRUE STORY, ZO PLAY THE DRUMS"
— Nipsey Hussle

"CAUSE NEVER KNOW MAYBE, THEY MIGHT WIND UP AT 429 BAUCHET LOCKED AWAY, PLUS CAN'T KEEP THE BOOTY CALLS WAITING"
— Ras Kass

"IT'S HELLA HOT WE PULL UP TO DOCKWEILER, THE SCENE IS SO LOVELY IT MAKE ME WANNA HOLLA"
— Defari

"I EAT AT CHANO'S & LA BARCA, NOT TACO BELL, AND IF YOUR NOT FROM THE CITY THEN YOU SHOULD PROBABLY BAIL"
— Thes One

"LOOKING RIGHT CAUSE MY SHIT IS TIGHT, BLAZING BLUNTS TO CITY LIGHTS ON SUNSET & CRESCENT HEIGHTS"
— Fatlip

"BANKED A QUICK LEFT CAUSE THERE'S MORE OF THEM DOWN ON CRENSHAW & VERNON, WATCH THE CURB WHILE I'M TURNIN"
— K-Dee

"TO MY BL FROM HOLL BELLFOR SCOTT, REE TO PHLOX KNOW THE S
— Scarfa

"GREW UP IN MID-CITY CALIFORNIA 1981, SYCAMORE AVENUE RIGHT OFF LA BREA AND WASHINGTON"
— 2Mex

"MY FAVORITE BITCH AT DREAM BE STRIPPING AROUND 2, SHE LOVE TO SAY 'I FUCK WITH YOU, THANK YOU FOR COMING THROUGH'"
— Wale

"MET A BITCH AT THE VERSACE STORE, SAID SHE SUCK IT 'TIL I AIN'T GOT NO MORE, ONLY IN L.A."
— Notorious BIG

"YOU KNOW ME AT THE GRAVEYARD SHIFT, GETTIN SPLIFFED, WE CAN TAKE IT DOWNTOWN LIKE FIGUEROA & 5TH"
— Thes One

"A HIGH-POST HO, A PERFECT WAY FOR ME TO GET DOUGH, HUH, HAVE HER SELLIN' ASS ON BRONSON AVE. & PICO"
— Hittman

"WRECKED THE RENTAL ON SANTA MONICA BOULEVARD, I WAS HEADED TO THE EL REY TO SLAP A SECURITY GUARD"
— Slug

"I MET HER IN THE GALLERIA SHOPPING, BUYING GIFTS FOR SOME GUY THAT SHE DATING"
— Scarface

"MOVE, EVERY SCRIPT'S LIKE MIRAMAX, SMASH THE BIG BOY, TOTALLED IT, WILSHIRE & FAIRFAX"
— Ghostface Killah

"HUMBLE OLD ME HAD TO FLEX FOR THE FOLKS, DOWN IN MUSCLE BEACH PUMPING IRON AND BONE"
— Frank Ocean

"GET THE DEPOSIT SHIT AT MA FEELIN' M I DON'T NEED AN EX
— Childish G

"NO CONCERN AS I MAKE A LEFT TURN ON THE SHAW OFF OF JEFFERSON, FEELING AWFULLY NAKED IN THE U-TURN"
— Dr. Dre

"NI&&AS AIN'T BEEFING WITH A HAMBURGER, I'M ON ROSECRANS NI&&A AT TAM'S BURGERS"
— YG

"PLATINUM CUTS FROM Q ON CRENSHAW & LEIMERT SO WHAT'S CRACKING FOLKS DOING THE MOST"
— Ras Kass

"MY BIRTHPLACE, MY HOME AND I'LL BE BURIED ON PRAIRIE, ACROSS THE STREET FROM WHERE I WAS BORN IN LA"
— Chace Infinite

"ON 51ST & FIG GREW UP ABOUT 10 MINUTES FROM THE REAL RICKY"
— Schoolboy Q

"WE MAKIN' DOPE LIKE HOOVER & PICO, MOVE SLOW BE POLITE AND EVERYTHING'LL BE ALRIGHT"
— Double K

"I'M SMOKIN' DOPE IN FRONT OF DOPE ON FAIRFAX, JET LIFE NI&&A, THESE LEAR RAPS"
— Smoke DZA

"BUN B THE OG LIKE '95 AIR MAX, NEON GREEN OUTTA FLIGHT CLUB OFF FAIRFAX"
— Bun B

"I WENT TO JOHN BURROUGHS FIRST, GIRLY WAS A MEANIE, CHEATED ON ME WITH A DUDE THAT USED TO GO TO UNI"
— Luckyiam.PSC

"CAN'T LE GOVERNME ME HOW MY LOOKING, ROSECRA CENTRAL TO DUCK THE C BOOKIN
— Kendric

"HITTING DONUTS IN THE INTERSECTION, 105 EXIT CENTRAL, NIGGA EASTSIDE WATTS NOTHING RESIDENTIAL"
— Jay Rock

"SAY WHAT UP TO MY MAN KATRELL, AT JOYRICH OFF OF SPAULDING & MELROSE"
— Y.D. (U-N-I)

"I'M JUST TRYNA WIN FOR 'EM SLIDE UP LA BREA BABY, HIT THE 10 FOR 'EM"
— Dom Kennedy

"TO MY BLOCK, FROM HOLLOWAY, BELLFORT TO SCOTT, REED ROAD TO PHLOX, WE KNOW THE SPOTS"
— Scarface

"GOT STREET POWER FROM THE WATTS TOWERS TO HOWARD HUGHES, HOW WOULD YOU BEOME ME, I DON'T DO WHAT YOU COWARDS DO"
— Crooked I

"I'M SIPPIN ON PIÑA COLADA, TWO BLOCKS OFF LA CIENEGA AT THE RAMADA"
— Diamond D

"I DID A SHOW IN CHICAGO ON THE FIRST, NOW I'M BACK IN LA LIKE CHICAGO & 1ST"
— Evidence

"I TAKE TWO BIG PUFFS AND I HOLD IT IN, I'M ON THE GOLDEN GATE BRIDGE ON MY WAY TO MARIN I BEEN IN THE GAME, I JUST PRAY THAT I WIN"
— Berner

"I'M STROLLING ON DEL AMO BOULEVARD TOWARDS THE ARCO TO GET ANOTHER BLACK N MILD MY LUNGS MUST LOOK LIKE CHARCOAL"
— Ab Soul

"LEFRAK IS ILLEGAL CONTRAC 'EM BACK UP THE MAG